Lundahl & Seitl

New Originals

KUNSTMUSEUM BONN

Lundahl & Seitl

New Originals

mit einer Werkübersicht von /
with an overview of works from
2007 – 2016

Wienand

Inhaltsverzeichnis · Contents

In memory of John Berger (1926 – 2017)

"I had a dream in which I was a strange dealer, a dealer in looks or appearances. I collected and distributed them, and in the dream I had just discovered a secret. I discovered it on my own, no help. The secret was to get inside whatever I was looking at, get *inside* it.

When I woke up from that dream I couldn't remember how it was done. And I now no longer know how to get inside things."

John Berger in '*John Berger or The Art of Looking*'
(A film by Cordelia Dvorak)

Vorwort · Foreword

Stephan Berg

Jenseits der banalen Erkenntnis, dass menschliche Persönlichkeitsbildung ohne Erinnerungsvermögen zwangsläufig zum Scheitern verurteilt ist, stellt sich die weit wesentlichere Frage, woran wir uns eigentlich erinnern, wenn wir uns erinnern. Lässt die Erinnerung tatsächlich das reale Ereignis wiederauferstehen oder rekonstruiert sie es „nur" als Bild, das unser Gedächtnis von diesem Ereignis gespeichert hat? Und weiter gefragt: Sind wir überhaupt in der Lage, wesentliche Erinnerungen selbst abzurufen, oder müssen wir dazu, wie Proust dies in seiner *Suche nach der verlorenen Zeit* formulierte, auf die Hilfe der *memoire involontaire*, also der sich unwillkürlich und nicht steuerbar einstellenden Erinnerung zurückgreifen?

Die Frage, wie Erinnerung, Erinnerungs-Bild und authentisches Ereignis zusammenhängen, spielt eine wesentliche Rolle in dem von dem schwedischen Künstlerpaar Lundahl & Seitl eigens für das Kunstmuseum Bonn entwickelten Projekt *New Originals*. Die vergangenen anderthalb Jahre haben sich der ursprünglich als Maler ausgebildete Christer Lundahl und die Choreografin und Performerin Martina Seitl mit den Sammlungsschwerpunkten des Hauses auseinandergesetzt und daraus einen Parcours geschaffen, der prominente Originale von Max Ernst, Joseph Marioni, Stephan Huber und dem August-Macke-Schüler Paul Adolf Seehaus in einer interaktiven Audiotour so mit ihren kopierten Gegenstücken verzahnt, dass die Besucher auf eine produktive Weise mit der verwirrenden

Frage konfrontiert werden, was sie eigentlich gesehen haben, wie sie selbst Kunstwerke erfahren und inwieweit die Weise, in der Original und Kopie zusammenhängen, vergleichbar ist mit der Art, wie ein reales Ereignis und die daraus abgespeicherte Erinnerung miteinander verbunden sind.

Die hier explizit versuchte Engführung zwischen Original und Kopie berührt dabei das Selbstverständnis jedes Museums schon deswegen grundlegend, weil – allen Erweiterungen des Kunstbegriffs und der heute möglichen totalen Reproduzierbarkeit des Kunstwerks zum Trotz – für unser Bewusstsein nach wie vor die Aura des Originals eine zentrale Rolle spielt. Zudem berührt die Kombination von Original und Kopie natürlich auch das Thema der Fälschung, das innerhalb des Kunstbetriebs ja gerade in den letzten Jahren durchaus traurige Prominenz erlangt hat. In seinem epochalen Roman *The Recognitions* (1955; *Die Fälschung der Welt*) hatte der amerikanische Autor William Gaddis anhand eines genialen Fälschers flämischer Malerei diese Konstellation schon einmal brillant durchgespielt und dabei die interessante These aufgestellt, dass der Fälscher, anders als der penibel das Original nachbetende Kopist, in der Lage sei, auch die schlechteren Partien des Originals in dessen Geist zu verbessern und folglich sein Werk dem Original, das er quasi neu erschafft, überlegen sein könne. Ohne diesen Gedankengang hier weiter ausführen zu können, zeigen doch schon diese knappen Bemerkungen, auf welch

fruchtbarem und für die Diskussion zentraler Museumsinhalte wesentlichen Feld sich die Arbeit von Lundahl & Seitl bewegt.

Ich freue mich sehr darüber, dass das Künstlerpaar nach seinen Arbeiten u.a. für die Tate Modern, die Tate Britain und die Whitechapel Gallery in London, das Magasin III in Stockholm, das SMAK in Gent und das Kunstmuseum in Bern nun mit den *Neuen Originalen* ein neues Kapitel seiner erweiterten performativen Praxis für Bonn entwickelt hat, das gleichzeitig den Startpunkt für einen neuen programmatischen Schwerpunkt im Kunstmuseum Bonn bildet.

Mein großer Dank gilt Christer Lundahl und Martina Seitl für die konstruktive Zusammenarbeit und für die Sorgfalt und Energie, mit der sie dieses herausfordernde Projekt entwickelt und begleitet haben.

Für die großzügige finanzielle Förderung der Ausstellung geht ein ebenso großer Dank an die Stiftung Kunst der Sparkasse in Bonn wie für die Kooperation an das Iaspis-Programm, The Swedish Arts Grants Committee und den Swedish Arts Council. Ohne das Know-how und die Unterstützung der Firmen Nagoon, die die gleichnamige Plattform Nagoon entwickelten, Sennheiser und Sony, hätte das anspruchsvolle Vorhaben in seiner jetzigen Form nicht durchgeführt werden können. Dafür bedanke ich mich sehr herzlich. Bei Sally Müller, die als wissenschaftliche Volontärin am Kunstmuseum Bonn diese vielschichtige Ausstellung selbstständig konzipiert und realisiert hat, bedanke ich mich sehr für die Präzision und Professionalität, mit der sie alle Aspekte dieser komplexen Unternehmung stets im Blick und im Griff hatte.

Beyond the banal recognition that the development of the human personality would inevitably be condemned to failure without its capacity for remembrance, a much more fundamental question arises as to what we actually remember when we recall things. Does human remembrance actually resurrect the real event, or does it reconstruct this occurrence 'only' as a picture stored in our memory? And furthermore: are we even able to summon up essential recollections ourselves, or must we hope, as Proust described in *Remembrance of Things Past*, to have recourse to *mémoire involontaire*, an involuntarily arising, non-controllable act of remembering?

The question as to the interconnection between memory, the recollected image and an authentic event plays an essential role in the project *New Originals*, which the Swedish artist duo Lundahl & Seitl created specifically for the Kunstmuseum Bonn and with which they are presenting themselves for the first time in Germany. For the last year and a half, Christer Lundahl, who originally trained as a painter, and the choreographer and performer Martina Seitl investigated the highlights of the museum's collection and developed an interactive audio walk that intertwines prominent originals by Max Ernst, Joseph Marioni, Stephan Huber and Paul Adolf Seehaus (a pupil of August Macke) with their own copied and elaborated counterparts. This is done in such a manner that visitors are productively confronted with the perplexing question as to what they have actually seen and how they themselves experience works of art, and to what extent the way in which the original and the copy are linked is comparable to the way a real event and the stored memory of it are connected to each other.

The close juxtaposition between original and copy explicitly undertaken here is already fundamentally involved with the self-concept of every museum because – despite all extensions of the notion of art, and notwithstanding the absolute possibility of reproducing a work of art today – the aura of the original continues to play an essential role in our awareness. Moreover, the combination of original and copy also inevitably involves the issue of the counterfeit which, especially in these last years, has acquired such saddening prominence. In his epochal novel *The Recognitions* from 1955, the American author William Gaddis brilliantly examined this constellation through the figure of an ingenious counterfeiter of Flemish painting, presenting the interesting thesis that the forger, in contrast to the meticulous subservience toward the original evinced by the reverent copyist, is capable of improving the less successful sections of the original in its own spirit, so that his work could actually turn out to be better than the original, which in a certain sense he has created anew. Although it is not possible to discuss this train of thought more fully here, these brief remarks already show that the works by Lundahl & Seitl operate upon a terrain that is extremely fertile and centrally important for the discussion of the contents of museums.

I am pleased that after their great works presented at institutions as Tate Modern, Tate Britain and the Whitechapel Gallery in London, the Magasin III in Stockholm, the SMAK in Ghent and the Kunstmuseum in Bern, the artist duo have now, with their *New Originals*, developed a new chapter in their extended performative practice, which is simultaneously serving as the point of departure for a new programmatic focus by the Kunstmuseum Bonn.

I would like to express my deep gratitude to Christer Lundahl and Martina Seitl for their constructive collaboration, as well as for the care and energy with which they developed and accompanied this challenging project.

An equal expression of gratitude goes to the Stiftung Kunst der Sparkasse in Bonn for their generous financial support of the exhibition, as well as the cooperation of the Iaspis programme, the Swedish Arts Grants Committee and the Swedish Arts Council. Without the know-how and support of the companies Nagoon, who developed the plattform Nagoon, as well as Sennheiser and Sony, it would not have been possible to realize the ambitious undertaking in its present form; I am very grateful for this indispensable assistance. As for Sally Müller who, working as an assistant curator at the Kunstmuseum Bonn, independently conceived and realized this challenging project, I sincerely thank her for the precision and professionalism with which she oversaw and handled all aspects of this complex undertaking.

Lundahl & Seitl
New Originals

Sally Müller

Das vollkommene Eintauchen in eine andere Welt der Filme, Computerspiele, erweiterten oder virtuellen Realitäten (*augmented* bzw. *virtual reality*) ist allgegenwärtig. Hierbei wird die Realität durch eine medial vermittelte Illusion ausgedehnt oder gar ersetzt. Neue technische Möglichkeiten, aber auch zeitgenössische Denkansätze wie der Spekulative Realismus unterstützen diese Entwicklung.[1] Hypothesen des Posthumanismus, denen zufolge der Mensch nicht mehr übergeordnet ist, sondern die künstliche Intelligenz die Herrschaft übernimmt, sind verbreitet. Gleichzeitig ist vom neuen Zeitalter Anthropozän die Rede, der Welt, deren Zentrum der Mensch ist, Urheber immenser Veränderungen des Planeten. Ohne die Verantwortlichkeit des Menschen für diese Eingriffe zu bestreiten, befragt dagegen der Spekulative Realismus kritisch die angenommene zentrale Position des Menschen und rückt das Interesse an der autonomen Realität der Welt, der Eigenständigkeit der Dinge in den Vordergrund. Nicht die menschliche Sicht auf die Welt entscheidet über deren Erscheinungsweise, sondern die Welt selbst.[2] Ist es deshalb so interessant, sich den Dingen so weit wie möglich zu nähern, sich in sie hineinzuversetzen, sie verstehen zu wollen, gerade weil sie nicht von unserem Bewusstsein abhängig sind, sondern uns als unabhängige Realität, als das Andere und Fremde gegenüberstehen?

Immersion, das Umgeben- und Umschlossen-Sein von einer anderen Welt, ist eine zunehmend wichtige Methode der zeitgenössischen künstlerischen Praxis. Seit 2003 nutzen Christer Lundahl und Martina Seitl immersive Techniken in ihren Arbeiten. Das Künstlerduo ist bekannt für seine international gezeigten performativen Audiowerke und situationsspezifischen Kunstwerke, die den Fokus auf die individuelle Wahrnehmung der Besucher und Besucherinnen legen. Christer Lundahl studierte Malerei am Central Saint Martins College of Art and Design in London sowie an der Akademie für Kunst, Architektur und Design in Prag. Der Schwerpunkt Martina Seitls lag während ihres Studiums an der Middlesex Universität London und dem Trinity Laban Conservatoire of Music & Dance auf Performance-Kunst und Choreografie. Diese unterschiedlichen Ausgangspunkte der künstlerischen Biografien finden sich in den gemeinsamen Werken wieder. Das Duo arbeitet transdisziplinär und kombiniert in seinen zeitbasierten Installationen Bewegung und Wahrnehmungsschulung mit neuester Technik.

New Originals (2017)

Lundahl & Seitls Werk *New Originals* (2017) wurde eigens für das Kunstmuseum Bonn entwickelt, womit die Künstler einen neuen Abschnitt ihrer Arbeitsweise markieren. Erstmalig bezieht sich eine audio-performative Arbeit von Lundahl & Seitl

nicht ausschließlich auf eine bereits definierte und besetzte räumliche Situation und wird nicht als Teil einer Gruppenausstellung oder als Event gezeigt, sondern findet als eigenständige Ausstellung über eine Zeitspanne von drei Monaten statt. *New Originals* ist spezifisch für einen Ort geschaffen, kann aber im Anschluss an die Ausstellung in Bonn, so wie es auch mit früheren Arbeiten des Künstlerduos geschah, an weitere Orte und Institutionen wandern und diesen angepasst werden. *New Originals* lädt dazu ein, sich Gedanken über die Herkunft von Bildern und die Entwicklung von Erinnerungen zu machen. Wie entstehen Bilder und wie erinnern wir uns an sie? Welche Rolle spielen Original und Kopie dabei? Durch die Auseinandersetzung mit Formen der gedanklichen Erschließung der Werke und der Erinnerung an Werke aus der Sammlung des Kunstmuseum Bonn werden in der Imagination jeder einzelnen teilnehmenden Person eigene, neue Originale hervorgerufen. Die Arbeit ist eine Installation mit einem Audiowalk als Kernstück, den man individuell erlebt. Dieser kommt ohne den Einsatz von weiteren Performern aus, während die Teilnehmenden in einigen früheren Arbeiten von Lundahl & Seitl teilweise durch Berührungen individuell geleitet wurden. Die Arbeit erweitert sich mithilfe der von Alex Backstrom für die Ausstellung verfassten Kurzgeschichte *Die Quallenfalle* in den literarischen Raum. Als Booklet erscheint die Erzählung zeitlich vor Eröffnung der Ausstellung. Somit wird die Thematik von *New Originals* schon in Form einer Geschichte eingeführt, die Bezüge zu den Bildinhalten ausgewählter Werke der Sammlung des Kunstmuseum Bonn herstellt. *Die Quallenfalle* erzählt von einer Person, die es fasziniert, in Kapseln gespeicherte Erinnerungen zu sammeln und weist auf die Möglichkeiten und Dimensionen der Vorstellungskraft hin.

Die Ausstellungsräume

Die Einbeziehung von Stücken aus der Sammlung des Kunstmuseum Bonn bestimmt die visuelle Präsentation von *New Originals* in zwei der insgesamt drei Ausstellungsräume.

Folgende Werke wurden aus der Sammlungspräsentation und aus den Depots des Museums ausgewählt: Paul Adolf Seehaus, *Leuchtturm mit rotierenden Strahlen* (1913); Max Ernst, *Grätenwald* (1926) und der Collageroman *La femme 100 têtes* (1929); Joseph Marioni, *Painting No. 13* (1998) und Stephan Huber, *Weisshorn* (1998), *Antelao* (2001), *Pelmo* (2001), *Sasso Lungo (Langkofel)* (2001), *Alte Welt/Neue Welt* (2009), *Geographie der Liebe/ Nervenbahnen der Abenteuer* (2011) und *La Ville*

Sentimentale VS. AIC (2013). Der Fokus auf Natur, Kartografie, Landschaft und Lichtquellen war für Christer Lundahl und Martina Seitl bei der Auswahl das verbindende Element, um die Szenerie der Ausstellung zu gestalten, in der ihr Audiowalk verankert ist. In *New Originals* begegnet man somit einer ungewohnten Kombination von Werken einer städtischen Kunstsammlung, die erst durch die Arbeit des Künstlerduos in einen neuen Zusammenhang gebracht und miteinander verbunden werden. Besucherinnen und Besucher folgen der Arbeit und damit der Abfolge in drei Räumen, wobei sie die Raumfolge beliebig von einem der beiden entgegengesetzten Zugänge betreten können. Die beiden Eingangsräume sind mit Werken aus der Sammlung bestückt, der von ihnen flankierte, mittlere Raum ist leer. Beim Betreten eines der äußeren Räume der Ausstellung ist man auf den ersten Blick von vertrauten Arbeiten umgeben, jedoch wird regelmäßigen Besucherinnen und Besuchern des Museums auffallen, dass das Arrangement von der üblichen Art der Präsentation vor Ort abweicht. Denn traditionell wird die Sammlung des Kunstmuseum Bonn in monografischen Künstlerräumen gezeigt, um die Entwicklung der jeweiligen Position zu verdeutlichen.[3]

Reaktivierung

Durch die Zusammenstellung einzelner Kunstwerke aus der Sammlung und ihren Einbezug in eine neue Arbeit von zeitgenössischen Künstlern vollzieht sich eine Reaktivierung und Belebung der Werke. Es werden neue Bezüge hergestellt und somit neue Einblicke in die einzelnen Arbeiten gewährt. Das Interesse von Künstlerinnen und Künstlern, sich auf andere Kunstwerke zu beziehen oder sie in die eigenen Arbeiten zu inkludieren, um neue Konstellationen zu erzeugen, beschreibt die Künstlerin Dora García in der für die Ausstellung *An Imagined Museum* angefertigten Zeitung *451 The Mnemosyne Revolution*:

„Ich erinnere mich, dass viele Künstlerinnen und Künstler behaupteten, Kunst aus Kunst zu machen. Das bedeutet, das Werk anderer Künstlerinnen und Künstler war für sie die Haupttriebfeder oder -motivation, um Kunst zu produzieren. Sie betrachteten Kunstwerke als Konstellationen, in denen jedes Kunstwerk mit einer Myriade weiterer Kunstwerke verknüpft war, und so wurden zwischen Kunstwerken aller Zeitalter zahllose Beziehungsvektoren gesetzt und wieder ausgesetzt. Wie eine in ein Billardspiel geschossene Kugel verschob jedes neue Kunstwerk plötzlich alle anderen Kunstwerke in diesen

Konstellationen, und neue Formen und Beziehungen traten hervor, um sich fortwährend wieder zu verändern, denn es gab einen endlosen Strom von Kunstwerken, die entstanden, entdeckt, neu entdeckt, neu gedeutet, noch einmal besehen wurden. Wie ein Vogelschwarm, wie der Sternenstaub, in ständiger Bewegung. Die Kunst verhielt sich als lebendiges System. Manche Künstlerinnen und Künstler studierten dieses Kunstsystem. Manche Künstlerinnen und Künstler machten aus diesem Kunstsystem Kunst. Es war eine unglaubliche Spirale, eine riesige Rückkopplung, eine erregende Supernova."[4]

Doch Lundahl & Seitl verwenden nicht nur Originale. Von zwei Gemälden fertigte Christer Lundahl Kopien an, die übrigen gezeigten Werke entstammen vervielfältigten Serien oder liegen als – ebenfalls in höherer Auflage publizierte – Buchdrucke vor. Auf diese Weise konnte das Künstlerduo die beiden außenliegenden Räume scheinbar identisch gestalten. Dies löst Irritation aus und motiviert zu einer Auseinandersetzung mit den Themen Original, Kopie und Erinnerung.

Auf die Frage danach, was Bilder im Allgemeinen auszeichnet, hat der Autor, Kunstkritiker und Maler John Berger, der insbesondere mit der Publikation *Ways of Seeing* und der dazugehörigen BBC-Serie in den 1970er-Jahren bekannt wurde, geantwortet: "Jedes Bild verkörpert eine Sichtweise."[5] Die im Bild manifestierte Sichtweise des Künstlers und der Künstlerin versuchen der Betrachter und die Betrachterin durch seine und ihre eigene Perspektive zu entschlüsseln. Berger fügt hinzu, dass jede Sichtweise von dem Wissen und Glauben des jeweiligen Betrachters und der jeweiligen Betrachterin beeinflusst ist.[6] Wir schauen also Bilder ganz unterschiedlich an, verstehen und interpretieren sie auf unterschiedliche Weise. Beeinflusst sind wir durch unsere Vorkenntnisse, davon, wie wir die Dinge sehen und wie diese für uns zueinander stehen. Über das Sehen hinaus erhalten Besucherinnen und Besucher durch *New Originals* Informationen in Form von Geräuschen und Stimmen. Die Klanglandschaft zu jedem Bild steht im Fokus. "Klang ist nicht nur allgegenwärtig: Auf den Klang kommt es an."[7] Sprachliche und nichtsprachliche Klänge gehören zu Situationen und Bildern dazu. Joseph Grigely beschreibt in seinem Text "Soundscaping" die Visualisierung von Klängen und behauptet zudem, dass Bilder Klänge besitzen: "Eigentlich haftet jedem Bild auf der Welt Klang an. [...] Ich habe etwas über das Sehen gelernt: Wenn man Bilder lange genug anschaut, beginnen sie Klänge zu erzeugen."[8] Lundahl & Seitl laden uns ein, an dieser Lehrstunde teilzunehmen.

Durch Klänge und gesprochene Texte aus den Kopfhörern und Textnachrichten auf dem Mobiltelefon erweitern Lundahl & Seitl den Erlebnisraum der Bilder, Objekte und Bücher.

Diese Mittel erlauben es, sich den Werken in anderer Weise anzunähern und sich in sie hineinzuversetzen.

Der leere Raum

Zwischen den beiden einander kopierenden Ausstellungsräumen befindet sich Leere: ein weißer Ausstellungsraum. Wenn dieser betreten wird, eröffnet sich der Raum der Erinnerung. Die sogenannten Weißbrillen werden aufgesetzt, an denen auch die bisher in den Händen gehaltenen Mobiltelefone befestigt werden. Die Augen sind von der Außenwelt isoliert und ein meditativ anmutender Prozess beginnt. Die Reflexion über das vorher Gesehene setzt ein. Der Sehsinn wird beruhigt und der Hörsinn durch Stimmen und Geräusche aus den Kopfhörern weiterhin aktiviert. Bei der Weißbrille handelt es sich nicht, wie im ersten Moment anzunehmen wäre, um eine Virtual-Reality-Brille, die weitere Eindrücke und Bilder liefert, sondern um das Gegenteil: Sie ist lediglich eine Verdeckung, die dabei hilft, ins Nichts zu schauen und sich komplett auf sich selbst zu konzentrieren. Das darauf befestigte Mobiltelefon dient als Lichtquelle. Wechselnde Farben unterstützen das jeweilige Vorstellungsmoment. Der Prozess des Erinnerns an die Begegnung mit den Bildern und Objekten im vorher gesehenen Ausstellungsraum beginnt.

Wenn wir laut John Berger Bilder auf unterschiedliche Weise entschlüsseln, erinnern wir uns dann auch auf verschiedene Art und Weise an sie? Lundahl & Seitl führen uns in einen leeren, nicht mit realen Objekten besetzten Raum. Leere Räume und Flächen sind immer wieder Thema in Malerei, Musik und Poesie. In einer Kultur des Bildes, der Bebilderung und Darstellung der Welt hat man zugleich versucht, auch dem Unsichtbaren eine Gestalt zu geben. Die Einsicht, dass die Darstellung der Welt im Bild an Grenzen stößt oder sogar scheitert, führt zur Diskussion über den gänzlichen Verzicht auf das Bild. Erinnern wir uns an Yves Klein, der mit seiner Installation *The Void* im Jahr 1958 in der Galerie Iris Clert in Paris die Leere als gesamten Ausstellungsinhalt wählte und dadurch seine "malerische Suche nach einer ekstatischen und unmittelbar mitteilbaren Emotion"[9] zum Ausdruck brachte. Lundahl & Seitls Arbeit *New Originals* führt Bild und Leere, Wahrnehmung und Vorstellung, Anwesenheit und Abwesen-

heit im Ausstellungsparcours der drei Räume ineinander. Aus diesem Ineinander bezieht sie ihre kreative und produktive Kraft.

Imagination

Im leeren Raum ist Platz für die Gegenwart eines Nicht-Anschaulichen, im leeren Raum fällt die Realität der beiden äußeren Räume zusammen, aber als Realität von Vorstellung und Erinnerung. Nur beim Übergang vom inneren, leeren Raum zum äußeren der realen Objekte kann das Vorgestellte wieder durch die Anschauung überprüft werden. Gerade indem eine Leerzone definiert wird, in die das zuvor Gesehene mitgenommen und die vom zuvor Gesehenen gestaltet wird, intensivieren die beiden Künstler den Wechsel von Original und Reproduktion, Echtem und Falschem, eine Bewegung, die an kein Ende kommt, eine Frage nach der Wahrheit, die unbeantwortet bleibt. Im mittleren, leeren Raum erinnern sich die teilnehmenden Personen an die im ersten Raum gesehenen Bilder. Bei dem Versuch, sie in der Erinnerung wiederherzustellen, entsteht keine Reproduktion, sondern ein neues Original (*New Original*). In dieses neue Original fließen Erinnerungen an das gesehene Werk, aber auch eigene Gefühle und eigenes Wissen ein. Die Imagination wird derartig intensiviert, dass die Mitwirkenden zum Beispiel glauben, sich in einem Grätenwald oder auf einer Bergspitze zu befinden. Auch wenn diese *New Originals* vom selben Werk ausgegangen sind, entstehen individualisierte Schöpfungen, die für alle Teilnehmenden eine eigene Gültigkeit haben. Auf dem von Lundahl & Seitl gebauten Parcours der Kunstwerke und Texte, der Geräusche und des Lichts entsteht in jedem Besucher und in jeder Besucherin eine eigene Sammlung von Bilderlebnissen, die ihn und sie auch nach dem Ausstellungsbesuch begleitet.

Die Reflexion

Gleich welcher der beiden äußeren Ausstellungsräume auf der Reise als letzter betreten wird, dieser dient als Reflexionsmoment über das ganzheitlich Erlebte. Vermutlich gehen die Besucher beim Betreten des letzten Raumes davon aus, dass sie sich wieder im ersten befinden. Zumindest bis zu dem Punkt, an dem sie realisieren, dass die beiden äußeren Räume sich spiegeln. Im Laufe der gesamten Arbeit haben sie dreimal den gleichen Raum auf unterschiedliche Art und Weise *gesehen* und ihn entweder real oder gedanklich betreten. Sie haben mit den Augen, aber auch durch das Schließen der Augen gesehen:

„Gewöhnlicherweise bedeutet Sehen die Augen zu öffnen und die Außenwelt anzuschauen. Man kann auch anders sehen: Die Augen werden geschlossen und man schaut die eigene innere Welt an. Ich glaube, das Beste ist, ein Auge geschlossen zu halten und nach innen zu schauen, das ist das innere Auge. Das andere Auge ist auf die Realität fixiert und das, was um einen herum in der Welt passiert. Wenn man eine Synthese aus diesen zwei wichtigen Welten zieht, kommt man zu dem Ergebnis der Synthese von objektivem und subjektivem Leben.“[10]

So beschreibt der Surrealist Max Ernst die ideale Weise einer Wahrnehmung, die äußeres und inneres Sehen miteinander verbindet. Auch in *New Originals* schauen wir mit einem geschlossenen und einem geöffneten Auge. Die Arbeit ist somit eine Wahrnehmungsschulung durch Performativität, Partizipation mithilfe technischer Medien.

Die Medien des Unsichtbaren

Um den Prozess der Wahrnehmung, der Erinnerung und des Vergleichs zu ermöglichen, bedarf es auch einer unauffälligen und doch zentralen Technik, die alles miteinander verknüpft (Kopfhörer, Mobiltelefone, Weißbrillen, Beacons). Sie eröffnet den Einstieg in eine andere Welt über den Seh- und Hörsinn. Aber wie ist diese andere Welt der *New Originals* genau einzuordnen? Ist es Kunst zum Hören, Audiokunst, Audioguide oder ein Audiowalk? Und wo liegt der Unterschied? Audio- oder auch Klangkunst, eine Verschmelzung aus freier Kunst und Musik, hat ihren Ursprung in der Musik und entwickelt sich von ihr ausgehend weiter in das künstlerische Feld. Mit ihren Arbeiten machten insbesondere John Cage und Karlheinz Stockhausen in den 1960er-Jahren und Laurie Anderson in den 1970er-Jahren die Klangkunst bekannt. Als inspirierend hat sich erwiesen, dass auch Geräusche neben Klängen als akustische Ereignisse künstlerisch emanzipiert wurden. Durch das Ars Electronica Festival, das seit 1979 inzwischen jährlich in Linz stattfindet, entwickelte sich die elektronische Klangkunst weiter und öffnete sich insbesondere dem interaktiven Kunstbereich.[11]

Der klassische Audioguide hingegen ist als transportabler Museumsführer, der die Objekte zum Sprechen bringen soll, in den 1970er-Jahren aufgrund eines als zunehmend wichtig erkannten Bildungsauftrages der Museen entwickelt worden.[12]

Personen ohne Fach- und Vorkenntnisse sollte es der Audioguide erleichtern, Zugang zu weiteren Informationen über die Ausstellungsstücke direkt vor Ort zu erhalten. Er dient als Alternative und Ergänzung zu Wandtexten und Führungen. Nummernschilder neben den Ausstellungsobjekten helfen bei der Zuordnung der über die Werke zu hörenden Informationen. Mittlerweile sind Audioguides nicht nur über Leihgeräte nutzbar, sondern auch über eigene Endgeräte, wie Smartphones und Tablets, auf die die Software gespielt werden kann. Der Audioguide entwickelte sich über die Jahre zum Multimedia-Guide und kann weiteres Bild-, Klang- und Videomaterial bereitstellen. Audio- wie auch Multimedia-Guides sind meist linear oder punktuell strukturiert und lassen die Nutzer gezielt eingespeiste Wissensbeiträge abrufen.[13] Interaktive Versionen, bei denen die Besucherinnen und Besucher selbst Fragen stellen, ermöglichen zum Beispiel Programme, die eine über WhatsApp betriebene Form des Audioguides durch Text- und Sprachnachrichten anbieten. Hierbei rückt das Publikum mehr ins Zentrum und kann gezielter artikulieren, welche Wissenslücken gefüllt werden sollen. In jedem Fall geht es um ein Vermittlungswerkzeug, das einen didaktischen Zweck erfüllt. Das geschlossene System gibt den Teilnehmenden die Möglichkeit, sich abzugrenzen und konzentriert weitere Informationen über die Ausstellung sowie darüber hinaus zu konsumieren.

Der Audiowalk, auch Soundwalk genannt, entstand in den 1950er-Jahren und beinhaltete ursprünglich eine Klanglandschaft, die ohne Unterbrechung aufgenommener Klang war. Das Abbilden der Atmosphäre einer Landschaft stand im Fokus, wie schon bei John Cages *Imaginary Landscape* (1939).[14] Diese Klanglandschaften haben das Medium über die Zeit erweitert. 1999 hatte Janet Cardiff ihren ersten Erfolg mit *The Missing Voice* in London – einem Audiowalk durch einen Teil der Großstadt, der ganz individuell erlebt wird.[15] Sie entwickelt bis heute, mittlerweile gemeinsam mit George Bures Miller, Audio-, Video- und Telefon-Walks. Diese sind ortsspezifisch und finden im Innen- wie im Außenraum statt. Neben diesem Duo haben andere Künstler ähnliche oder sogar von Cardiff/Miller inspirierte Audioarbeiten geschaffen wie Rimini Protokoll, Poste Restante, Osynliga Teatern und Alex Reynolds. Der Audiowalk kann als eine Mischung aus Klangkunst und Audioguide beschrieben werden. Besonders wichtig ist, dass es sich hierbei um ein eigenständiges Kunstwerk handelt, das nicht als Instrument didaktischer Vermittlung funktioniert. Die Einbindung der Umgebung gehört beim Audiowalk ganz na-

türlich dazu, er ist aber nicht allein dazu da, die Umgebung zu beschreiben. Die Umgebung bildet die Szenerie, in der sich die Hörenden mit dem Audiowalk befinden und bewegen.

Auch das Künstlerduo Lundahl & Seitl geht von der Audiotechnik aus, die alle individuell einbindet. Darüber hinaus kreieren sie keine rein lineare, sondern eine eher netzartige, offene Struktur, um die Arbeit *New Originals* erfahrbar zu machen. Zwar gibt es eine Abfolge in diesen Räumen, innerhalb dieser Struktur kann die Arbeit aber individuell gesteuert werden, indem man sich dem Werk aus der Sammlung nähert, das gerade die Aufmerksamkeit weckt. Das zentrale technische Medium von *New Originals* ist eine Anwendungssoftware, kurz App, die über in der Ausstellung bereitgestellte Smartphones zugänglich ist. Die in die App eingespeiste Arbeit besteht aus Audiospuren einer Erzählerstimme und Geräuschen, die die Teihnehmenden über Kopfhörer hören, sowie Textnachrichten mit weiteren Informationen, die sie in den beiden äußeren Räumen über das Smartphone erhalten. Die Stimme in *New Originals* gibt Beschreibungen, stellt Fragen, äußert Behauptungen, liefert künstlerische Interpretationen und erteilt Handlungsanweisungen.

Die Positionierung der Mitwirkenden wird durch eine Sender-Empfänger-Technik gesteuert, somit sind sie im Ausstellungsraum zu lokalisieren und der passende Inhalt kann abgespielt werden. Durch die Textnachrichten, die Weißbrillen und die eingesetzten Lichteffekte geht Lundahl & Seitls *New Original* über den klassischen Audiowalk hinaus. Es handelt sich insgesamt um eine vielschichtige Installation, in der Kunst und Technik ineinandergreifen, wodurch es darüber hinaus zu Wissensproduktion (*knowledge production*) kommt. Hierbei entwickelt und realisiert sich die Kunst mithilfe der technischen Möglichkeiten, und die Technik entwickelt sich durch die künstlerischen, innovativen Inhalte, die es gilt umzusetzen. Im Vordergrund der finalen Arbeit stehen aber insbesondere das Eintauchen, die totale Immersion und die konzentrierte Teilnahme jedes und jeder Einzelnen.

Immersion

Audiotechnik, Partizipation und Immersion sind zentrale Aspekte in den Arbeiten des Künstlerduos Lundahl & Seitl, wobei die Basis jedes Kunstwerks darin besteht, die Teilnehmenden einzubeziehen und sie zu Hauptakteuren zu machen. Partizipation ist hier die grundlegende Methode. „Im Zentrum steht dabei häufig die Figur des Kunstbetrachters oder Ausstel-

lungsbesuchers, der programmatisch aus seiner unterstellten körperlich passiven, kontemplativen Rezeptionshaltung befreit werden soll, indem er intellektuell wie physisch in die Realisation einer künstlerischen Arbeit involviert wird",[16] wie es Silke Feldhoff in ihrer Dissertation *Zwischen Spiel und Politik. Partipation als Strategie und Praxis in der bildenden Kunst* beschreibt. Partizipation und Performativität in künstlerischen Werken treten vermehrt in der zeitgenössischen Kunst auf. Heutzutage mag man „[…] mit Partizipations-Strategien der Empathielosigkeit und dem Vorurteil der existentiellen Entleerung des post-modernen Menschen ein Gegengewicht setzen";[17] es ist jedoch „kein exklusives Thema unserer Tage. Vom Barock über das 19. Jahrhundert bis in die Unterhaltungsindustrie der Gegenwart"[18] finden sich partizipatorische Ansätze.

Seit den 1950-/60er-Jahren entwickeln sich Partizipation und Performance zu wichtigen künstlerischen Strategien. *New Originals* realisiert sich nur durch die aktive Teilnahme des Publikums, durch die Handlung jeder Einzelperson und deren immersive Einbindung. „Immersion bedeutet salopp gesagt ‚eintauchen'. Immersion ist ein Schlüsselphänomen unserer Zeit, das die Erfahrung oder das Gefühl einer vollumfänglichen Einbettung in die eigene Umwelt beschreibt. Wenn diese Umwelt artifiziell ist, gehen wir also im Kunstwerk auf – es verschwindet, das Medium wird unsichtbar, wir sind ‚drin'."[19] Um eine Immersion zu schaffen, wird meist eine Welt aus Filmen, digitalen Bildern oder umschließender virtueller Realität aufgebaut. In diese künstlich erzeugte Welt tauchen die teilnehmenden Personen körperlich und geistig ein. Um ein bloßes Eintauchen in solche digitalen Bilder geht es aber bei Lundahl & Seitls Werken nicht. Hier sind es die durch die eigene Imagination geschaffenen Bilderwelten – die neuen Originale, *New Originals* –, die jeder in sich aufbaut und als Realität betreten kann. In *New Originals* geschieht dies durch Technik, die die Bewegung der Wahrnehmung und Vorstellung fördert. Die Besucher schaffen sich ihre eigene Illusion, der eigene Körper scheint dabei gleichzeitig im Jetzt und im Dort zu sein. Eine durch die Stimme aus den Kopfhörern skizzierte Welt wird durch den Hörsinn wahrgenommen und weiterentwickelt. Hier taucht das Bewusstsein in eine Welt ein und nimmt den im Jetzt verhafteten Körper mit in die Erlebniswelt. Das im digitalen Raum Suggerierte kann aber nur durch die Präsenz im realen Raum ausgetragen und somit dort erlebt werden. Das digital Erzeugte und real Verhaftete hängen unmittelbar zusammen. Gleichzeitig ist jeder Person bewusst, dass alles von der eigenen Imagination abhängig ist und der eigens aufgebauten Welt getraut werden muss, damit die Arbeit funktioniert. Wird die Imagination hinterfragt, funktioniert das Werk nicht. Dieses Paradox mag im Weg stehen oder zu viel Kreativität verlangen, aber im Kern stehen das Vertrauen und die Bereitschaft, sich auf diese Welt einzulassen, um sich selbst die Illusion nicht zu nehmen. Fabienne Liptay spricht mit Verweis auf Roland Barthes von den zwei Körpern der Teilnehmer immersiver Kunst.[20] Barthes erklärt dieses widersprüchlich anmutende Gefühl bezogen auf das Medium Film: „[…] Immersion als ein paradoxales Erleben verstehen: eine Erfahrung, weder hier noch dort zu sein, sondern in einer instabilen ‚Zwischenzone' der Wahrnehmung."[21] Auch nach Barthes ist der Körper zweigeteilt: „[…] als hätte ich zwei Körper gleichzeitig",[22] wie er 1975 in dem Text „Leaving the Movie theater" schreibt. Und „[…] in einen künstlichen Bildraum eintauchen, ohne jemals die Koordinaten der realen Umgebung aus ihrem Bewusstsein auszublenden."[23]

In *New Originals* sind Kunstwerke materiell präsent und werden zugleich immateriell in der Vorstellung erzeugt. Die von Barthes benannte instabile Zwischenzone wird so auf individuelle Weise erkundet. Es ist, als könnten die Teilnehmenden in *New Originals* die betrachtende Position verlassen und Teil der Wirklichkeit des Bildes werden. *New Originals* stellt das Publikum vor die Kunstwerke als faktisch materielle Gegebenheit, verlangt und ermöglicht aber in einer Konstruktion von Räumen, Texten und Geräuschen zugleich eine besondere Annäherung an die Bilder, ihre Aneignung und Verwandlung, die über eine oberflächliche, statische Wahrnehmung des Gegebenen hinausgehen und eine Erfahrung der Realität als offenen Prozess ermöglichen.

1 Der Spekulative Realismus wurde erstmals 2007 bei der Konferenz „Speculative Realism" am Londoner Goldsmith College thematisiert und setzt beim Korrelationismus, der von dem Philosophen Quentin Meillassoux benannt wurde, an.

2 Deutschlandfunk, http://www.deutschlandfunk.de/spekulativer-realismus-ueber-eine-neue-art-auf-der-erde-zu.1184.de.html?dram:article_id=346024 (abgerufen am 22.12.2016).

3 Kunstmuseum Bonn, *Vom Rheinischen Expressionismus bis zur Kunst der Gegenwart*, Bonn 2012, S. 9, 10.

4 Dora García, *451 The Mnemosyne Revolution*, newspaper for the exhibition *An Imagined Museum – Works from the Centre Pompidou, Tate and MMK collections*, Museum für Moderne Kunst, Frankfurt a.M., Centre Pompidou, Metz, Tate Liverpool, 2016, S. 19–20. (Übers. Stefan Barmann)

5 John Berger, *Ways of Seeing*, 1972, S. 9. John Berger, *Sehen. Das Bild der Welt in der Bilderwelt*, 1974, Übers. Axel Schenk, S. 10.

6 Berger, 1974 (wie Anm. 5), S. 8.

7 Joseph Grigely, „Soundscaping", in: *Artforum*, Herbst 2016, S. 251 (Übers. Stefan Barmann).

8 Ebd., S. 260 (Übers. Stefan Barmann).

9 Nuit Banai: „Yves Kleins Abenteuer der Leere", in: *Yves Klein*, hg. von Oliver Berggruen, Max Hollein, Ingrid Pfeiffer, Ausst.-Kat. Schirn Kunsthalle Frankfurt, Ostfildern-Ruit 2004, S. 22.

10 Monitor BBC, 1961 Max Ernst: https://www.youtube.com/watch?v=6a6cw3Lgw94 (abgerufen am 31.12.2016) (Übers. Stefan Barmann).

11 http://www.aec.at/about/geschichte/ (abgerufen am 21.11.2016).

12 *Mitteilungen und Berichte aus dem Institut für Museumskunde*, Nr. 23, Akustische Führungen in Museen und Ausstellungen, Bericht zur Fachtagung im Filmmuseum Berlin, 2001.

13 Ebd., S. 8.

14 http://johncage.org/pp/John-Cage-Work-Detail.cfm?work_ID=100 (abgerufen am 20.12.2016).

15 http://cardiffmiller.com/artworks/walks/missing_voice.html# (abgerufen am 20.12.2016).

16 Silke Feldhoff, „Zwischen Spiel und Politik. Partizipation als Strategie und Praxis in der bildenden Kunst", 2009, S.7, https://opus4.kobv.de/opus4-udk/files/26/Feldhoff_Silke.pdf (abgerufen am 12.10.2016)

17 Max Glauner, Get Involved! Partizipation als künstlerische Strategie, in: *Kunstforum*, 240, *Get involved!*, S. 31.

18 Ebd., S. 28.

19 http://www.monopol-magazin.de/google-und-facebook-wollen-dass-wir-ihre-welt-nicht-mehr-verlassen (abgerufen am 20.12.2016).

20 Fabienne Liptay, „Neither Here nor There, The Paradoxes of Immersion", in: Fabienne Liptay, Burcu Dogramaci (Hg.), *Immersion in the Visual Arts and Media*, Leiden/Boston 2015, S. 87.

21 Roland Barthes, „En sortant du cinéma", in: *Communications*, 23, 1975, S. 104–107, zit. nach: Liptay 2015 (wie Anm. 20), S. 87 (Übers. Stefan Barmann).

22 Ebd. (Übers. Stefan Barmann)

23 Ebd. (Übers. Stefan Barmann)

Complete immersion in an alternate world of films or computer games as well as augmented or virtual reality is an omnipresent phenomenon. Reality is expanded or even replaced by a media-conveyed illusion. This development is supported by new technological possibilities as well as by contemporary conceptual approaches such as Speculative Realism.[1] There is a widespread presence of the hypotheses of post-humanism, according to which the human being is no longer in a superordinate position: predominance has been assumed by artificial intelligence. At the same time, there is talk of a new era of the Anthropocene, a world centred around the human being as the source of immense transformations to the planet. Without disputing human responsibility for these interventions, Speculative Realism turns a critical eye toward the supposedly central position of human beings and shifts a primary focus toward the autonomous reality of the world, the independence of things. It is not the human perspective regarding the world that determines the manner in which it appears, but the world itself.[2] Is this the reason why it is so interesting to make as close an approach as possible to things, to enter into their context, to understand them precisely because they are not dependent upon our awareness but instead stand opposite us as an independent reality, as otherness and foreignness?

Immersion, the state of being surrounded and enveloped by another world, is an increasingly important method of contemporary artistic practice. Ever since 2003, Christer Lundahl and Martina Seitl have used immersive techniques in their works. The artist duo is known for its performative audio works and situation-specific works of art which have been presented internationally and are centred around the individual perception of the visitor. Christer Lundahl studied painting at Central Saint Martins College of Art and Design in London as well as at the Academy for Art, Architecture and Design in Prague. During her studies at Middlesex University in London and the Trinity Laban Conservatoire of Music & Dance, Martina Seitl turned her attention to performance art and choreography. These varying points of departure in the biographies of the artists are mirrored in their collaborative works. The duo works in a transdisciplinary manner and, in its time-based installations, combines movement and perception training with the most recent technology.

New Originals (2017)

Lundahl & Seitl's work *New Originals* (2017) was developed expressly for the Kunstmuseum Bonn and marks a new phase in the way the artists work. For the first time, an audio-performative work by Lundahl & Seidl is not related exclusively to an already defined and occupied spatial situation and is not being presented as part of a group exhibition or as an event, but is instead taking place as an independent exhibition over a three-month stretch of time. *New Originals* was created for a specific site but – as has been the case with earlier works by the artistic duo – can wander to further locations and institutions, where it can be accordingly adapted. The work invites the visitor to give thought to the provenance of images and the development of memories. How do pictures arise and how do we remember them? What role is played therein by original and copy? Through the encounter with modes of mental access to the works and by recalling works from the collection of the Kunstmuseum Bonn, new and unique originals are summoned up in the imagination of each individual participant. *New Originals* is an installation with an audio-walk as the core piece which visitors experience individually. The audio-walk doesn't require the utilization of further performers, whereas in several earlier works by Lundahl & Seitl the participants were individually led, to some extent, by means of the sense of touch. Through the short story *Die Quallenfalle* ('The Jellyfish Trap') written by Alex Backstrom for the exhibition, the work extends into literary space. The story is appearing as a booklet prior to the exhibition opening. The theme of *New Originals* is accordingly already being introduced in the form of a narrative that establishes links to the pictorial contents of selected works from the collection of the Kunstmuseum Bonn. *Die Quallenfalle* tells of a person who is fascinated by collecting memories stored in capsules, and it points toward the possibilities and dimensions of the power of imagination.

The Exhibition Spaces

The inclusion of works from the collection of the Kunstmuseum Bonn determines the visual presentation of *New Originals* in two of what is a total of three exhibition spaces.

The following works were selected from the collection presentation and from the storerooms of the museum: Paul Adolf Seehaus, *Leuchtturm mit rotierenden Strahlen* (1913); Max Ernst, *Grätenwald* (1926) and the collage novel *La femme 100 têtes* (1929); Joseph Marioni, *Painting No. 13* (1998); and Stephan

Huber, *Weisshorn* (1998), *Antelao* (2001), *Pelmo* (2001), *Sasso Lungo (Langkofel)* (2001), *Alte Welt/Neue Welt* (2009), *Geographie der Liebe/Nervenbahnen der Abenteuer* (2011) and *La Ville Sentimentale VS. AIC* (2013). The focus on nature, cartography, landscape and sources of light was the connecting element for Christer Lundahl and Martina Seitl in making the selection in order to shape the scenes of the exhibition in which their audio-walk is anchored. Thus in *New Originals*, one encounters an unusual combination of works from a municipal art collection which, only through the intervention of the artist duo, are introduced into a new context and linked with each other. The visitor passes through *New Originals* and experiences a sequence of three rooms, which can be entered at either end through one of the entrances situated opposite each other. The two possible entrance rooms contain works from the collection, while the middle room is empty. Upon entering one of the outer rooms of the exhibition, one is at first surrounded by familiar works, but regular visitors to the museum will notice that the arrangement deviates from the customary style of presentation; customarily, the collection of the Kunstmuseum Bonn is shown in monographic artist spaces in order to clarify the development of the respective positions.[3]

Reactivation

The bringing together of individual works from the collection and their inclusion in a new work by contemporary artists causes a reactivation and enlivenment of those works. Cross-references arise and convey new insights into the individual works. The interest of artists in making reference to other works of art or including them in their own creations in order to create new constellations is described by the artist Dora Garcia in the newspaper *451 The Mnemosyne Revolution* prepared for the exhibition *An Imagined Museum*:

'I remember many artists said that they made art out of art. This means other artists' work was the main trigger or motivation for them to produce art. They saw artworks as constellations, every artwork related to a myriad of other artworks, there were endless vectors of relationships being made and unmade between artworks of all ages. Every new artwork, like a ball being shot in a billiard game, suddenly relocated all other artworks in these constellations, and new forms and relationships emerged, to change again constantly, because there was an endless flow of artworks being made, being discovered, rediscovered, reinterpreted, seen again. Like a flock of birds, like

the dust of stars, in permanent motion. Art behaved as a living system. Some artists studied this system of art. Some artists made art out of this system of art. It was an incredible loop, a gigantic feedback, a titillating supernova.'[4]

But Lundahl & Seidl do not only make use of originals. Christer Lundahl made copies of two paintings; the other works on display come from reproduced works or consist of printed books, likewise published in extensive print runs. In this way, the artists were able to shape the two outer rooms in a seemingly identical manner. This perturbs visitors and also motivates them to give thought to the themes of original, copy and memory.

In response to the question as to what characterizes images in general, the author, art critic and painter John Berger – who became known in the 1970s particularly through the publication of *Ways of Seeing* and the accompanying BBC series – replied: 'Every image embodies a way of seeing.'[5] The viewer endeavours to use his own perspective to decode the point of view of the artist that is manifested in the picture. Berger adds that every perspective is influenced by the knowledge and beliefs of the respective viewer.[6] So we look at pictures in entirely different ways; we understand and interpret them quite differently. We are influenced by our prior knowledge, by the manner in which we see things and how we consider them to be related to each other. Beyond the act of vision itself, the visitor is provided by the audio-walk with information in the form of noises and voices. The focus is on the acoustic landscape of each picture. 'It's not just that sound is everywhere: Sound matters.'[7]

Verbal and non-verbal sounds belong to situations and images. In his text 'Soundscaping', Joseph Grigely describes the visualization of sounds and makes the additional claim that images possess sounds: 'Virtually every image in the world has sound attached to it. […] I learned a lesson about looking: If you look at images long enough, they start making sounds.'[8] Lundahl & Seitl invite us to participate in this lesson. They use sounds and spoken texts from headphones as well as text messages on mobile telephones to expand the experiential space of pictures, objects and books. These means allow us to approach works in another way and to enter into them.

The Empty Space

There is empty space between the two exhibition rooms that are copies of each other: a white exhibition room. When it is entered, a space of remembering opens up. The visitor puts on the so-called sightless goggles to which is attached the mobile telephone that, up until now, was handheld. The eyes are isolated from the external world, and a seemingly meditative process begins. Reflection ensues regarding what has been previously seen. The visual sense is calmed and the auditory faculty is further activated by voices and noises from the earphones. In spite of what might be initially assumed, the sightless goggles are not a pair of virtual reality eyeglasses that provide further impressions and images, but the exact opposite: they are simply a covering that makes it possible to gaze into nothingness and concentrate completely on oneself. The attached mobile telephone serves as a source of light. Changing colours support the respective surges of imagination. The process of remembering and the encounter with the pictures and objects from the previously viewed exhibition space commences.

If, as according to John Berger, we decode images in varying ways, do we also remember them in different ways? Lundahl & Seidl usher us into an empty space not filled with real objects. Empty spaces and surfaces have repeatedly been the theme of painting, music and poetry. In a culture of the image, in the illustration and representation of the world, there has been a simultaneous endeavour to imbue the invisible with a shape. The recognition that the depiction of the world in pictures meets with limitations or even failure leads to a discussion about an entire renunciation of the image. Let us call to mind Yves Klein who, with his installation *The Void* at the Galerie Iris Clert in Paris in 1958, selected emptiness as the entire contents of the exhibition and thereby brought to expression his 'painterly search for an ecstatic and immediately expressible emotion'.[9] Lundahl & Seitl's work *New Originals* intermingles image and emptiness, perception and imagination, presence and absence in the progression through the three rooms of the exhibition. They derive their creative and productive power from this mutual interpenetration.

There is space in the empty room for the presence of something unseen; here the reality of the two outside rooms coincides, but as a reality of imagination and memory. Only in the transition from the inner, empty space to the external one of real objects can what has been imagined be examined by being looked at once again. Precisely because an empty zone is defined into which what was previously seen is ushered and which is shaped by what was seen, the two artists intensify the transition from original and reproduction, authentic and false, a movement that does not come to an end, a question regarding truth that remains unanswered. In the intermediate, empty space, the participant is reminded of the pictures seen in the first space.

The attempt to recreate them in memory does not give rise to a reproduction but rather to a new original, as indicated by the title itself. Memories of the seen work flow into this new original, and so do the individual's own feelings and knowledge. The imagination is so vividly intensified that the participants believe, for example, that they are in a forest of fishbones or at the summit of a mountain. Even if these *New Originals* proceed from the same work, they give rise to individualized creations that have their own validity for each participant. Along the pathway of artworks and texts, noises and light set up by Lundahl & Seitl, there arises in each visitor a personal collection of pictorial experiences that continues to exist after the visit to the exhibition.

Reflection

Regardless of which of the two outer exhibition rooms is entered last, it offers a moment of reflection about the entire experience. There is reason to suppose that, upon entering the final space, visitors assume they have reentered the first one. At least until they realize that the two outer rooms are mirror images of each other. Over the course of the entire work, they have viewed the same space three times in different ways and entered it either in actuality or in thought. They have seen it with their eyes, but also by closing those eyes:

> 'Seeing means usually you open your eyes and you look to the outside world. You can see another way: You close your eyes and you look into your inner world. And I believe the best thing to do is to have one eye closed and to look inside and this is the inner eye. With the other eye you have it fixed on reality what is going on around in the world. If you can make kind of a synthesis of these two important worlds you come to a result which can be considered as the synthesis of objective and subjective life.'[10]

This is how the Surrealist Max Ernst describes the ideal mode of a perception that links inner and outer sight. In *New Originals* as well, we gaze with both closed and open eyes. The work is thus a schooling of perception through performativity and participation with the aid of technological media.

The Media of the Invisible

In order to make possible the process of perception, remembrance and comparison, there is need for an unobtrusive but central technology that links all the individual objects with each other (headphones, mobile telephone, sightless goggles, beacons). This facilitates the entry into another world through the senses of sight and hearing. But how can this other world of the *New Originals* be precisely classified? Is it art to be heard – Audio Art, an audio-guide or an audio-walk? And wherein lies the difference? Audio Art or Sound Art, a mixture of free art and music, has its origin in music and proceeds to develop further into the artistic field. Sound Art became known particularly through the works of John Cage and Karlheinz Stockhausen in the 1960s and Laurie Anderson in the 1970s. It proved to be an inspiration that noises along with sounds became artistically emancipated as acoustic events. Through the Ars Electronica Festival, which has taken place annually in Linz since 1979, the art of electronic sound developed further and opened itself especially to the area of interactive art.[11]

The classic audio-guide, on the other hand, was developed during the 1970s as a transportable museum guide designed to imbue objects with a voice on the basis of an educational mandate for museums that was considered to be increasingly important.[12] The audio-guide was supposed to allow visitors without basic knowledge or detailed expertise to gain access to further information concerning the exhibited objects directly at the site itself. It serves as an alternative and complement to wall texts and guided tours. Numbered markers alongside the objects on display help visitors to attribute the information they are receiving to the corresponding works of art. In the meantime, audio-guides are not only available as objects to hire but can be integrated into the visitor's own device such as a smartphone or tablet, onto which the software can be downloaded. The audio-guide has developed over the years into a multimedia guide and can provide further pictorial, audio and video material. Audio-guides as well as multimedia guides are most often structured in linear sequence or with individual sections; they allow the user to deliberately call up stored pieces of knowledge.[13] Interactive versions in which the visitors themselves voice questions are made possible, for example, by programs that offer a WhatsApp-based form of the audio-guide through text and voice messages. Here visitors increasingly come to the fore and can more deliberately articulate which gaps in their knowledge should be filled. In any case, it is a matter of a mediatory tool that fulfills a didactic purpose. The closed system offers visitors the possibility of detaching themselves and concentrating on receiving further information about the exhibition as well as a wider context.

The audio-walk, also known as a soundwalk, arose during the 1950s and originally comprised a sound landscape that consisted of sounds recorded without interruption. The focus was on the depiction of the atmosphere of a landscape, as was already the case in John Cage's *Imaginary Landscape* (1939).[14] These sound landscapes expanded the medium over time. In 1999, Janet Cardiff had her first success with *The Missing Voice* in London – an audio-walk through part of that city that is experienced entirely individually.[15] She has continued right up until today – meanwhile together with George Bures Miller – to develop audio-, video- and telephone-walks. These are site-specific and take place in both internal and external spaces. In addition to this duo, other artists such as Rimini Protokoll, Poste Restante, Osynliga Teatern and Alex Reynolds have created similar audio works or even ones that are directly inspired by Cardiff/Miller. The audio-walk can be described as a mixture of Sound Art and audio-guide. Of particular importance is the fact that this is an autonomous work of art and not an instrument of didactic outreach. The inclusion of the surroundings is an inherent element of the audio-walk, which, however, is not there solely to describe the immediate environment. The surroundings constitute the scene in which listeners find themselves and embark upon the audio-walk.

The artist duo Lundahl & Seitl also proceeds from an audio technology that involves the individual visitor. Furthermore, these two artists do not create a purely linear structure but instead an open, networked context in order to facilitate the experience of the work *New Originals*. Even though there is a sequence in these spaces, the work can nonetheless be individually manipulated inasmuch as visitors approach whichever work from the collection happens to have caught their fancy at the moment. The fundamental technological medium of *New Originals* is an application software – in short, an app – which is accessible via the smartphones made available at the exhibition. The work fed into the app consists of soundtracks featuring a narrator's voice and noises conveyed to participants through headphones, as well as text messages with further information provided in the two outer rooms by means of smartphones. The voice in *New Originals* provides descriptions, asks questions, makes assertions, offers artistic interpretations and issues directives.

A transmitter-receiver technology makes it possible to determine the position of all the visitors within the exhibition space and to convey the appropriate information to them. By including text messages, sightless goggles and lighting effects, Lundahl & Seitl's *New Originals* transcends the classic audio-walk. All in all, this is a complex installation in which art and technology intertwine. The interplay between art and technology gives rise to knowledge production. Art develops and realizes itself with the help of technical possibilities, and technology is elaborated by the innovative, artistic contents that are supposed to be realized. The elements that come to the fore in the final work with particular prominence, however, are immersion and the participation of each person.

Immersion

Audio technology, participation and immersion are fundamental aspects of the works of the artist duo Lundahl & Seitl; the basis of each work of art consists of the inclusion of participants as major protagonists. Participation is the underlying method here. 'Frequently standing at the centre is the figure of the viewer of art or the visitor to the exhibition, who is supposed to be liberated from what is considered to be a physically passive, contemplative attitude of reception by becoming both intellectually and physically involved in the realization of an artistic work',[16] as Silke Feldhoff puts it in her dissertation *Zwischen Spiel und Politik. Partizipation als Strategie und Praxis in der bildenden Kunst* ('Between Play and Politics. Participation as Strategy and Practice in the Visual Arts'). Participation and performativity are appearing with increasing frequency in contemporary art. Today it is possible 'to use strategies of participation to offer a counterweight to the lack of empathy and the prejudice of existential emptying experience by post-modern human beings'.[17] But this is 'no exclusive theme of our era. From the Baroque through the nineteenth century all the way to the entertainment industry of the present',[18] participatory approaches can be found.

Ever since the 1950s and 1960s, participation and performance have developed into important artistic strategies. *New Originals* is realized only through the active involvement of the public, through the actions and immersive inclusion of every individual. 'To put it bluntly, immersion means "diving in". Immersion is a central phenomenon of our era that describes the experience or the feeling of a complete inclusion in one's own environment. When this environment is artificial, we merge into the work of art – it disappears, the medium becomes invisible, we're "inside".'[19] In order to create an im-

mersion, most often a world is built up out of films, digital images or an enveloping virtual reality. The participant plunges physically and mentally into this artificially created world. But Lundahl & Seitl's works are not concerned with a mere entrance into this sort of digital imagery. Here it is pictorial worlds created by one's own imagination – the *New Originals* – that each person builds up internally and can enter as reality. In *New Originals*, this occurs through a technology that supports the flow of perception and imagination. The participants create their illusions; their bodies seem to be simultaneously in the now and the there. A world sketched out through voices in the headphones is perceived and further developed through the sense of hearing. Here consciousness plunges into a world and takes the body bound to the now into an experiential world. What is intimated in the digital space, however, can only be carried out through a presence in real space, where it can thereby be experienced. There is a direct connection between what is digitally created and what is contained within reality. At the same time, everyone is aware that everything is dependent on the imagination of each individual and that it is necessary to trust the world one has built up in order for the work of art to function. If the imagination becomes subject to questioning, the work of art no longer functions. This paradox may come to be an obstacle or require too much creativity, but essentially it involves trust and a readiness to give oneself over to this world in order not to rob oneself of the illusion. Fabienne Liptay speaks in reference to Roland Barthes of the two bodies of the participants in immersive art. [20] Barthes explains this apparently contradictory feeling with respect to the medium of film as follows: '[…] understanding immersion as a paradoxical experience: an experience of being neither here nor there but in an unstable, perceptual "in-between" zone of perception'.[21] Barthes also asserts that the body is divided into two: '[…] as if I had two bodies at the same time',[22] as he writes in 1975 in the text 'Leaving the Movie Theatre'. And '[…] to immerse into an artificial image space without ever completely blocking the co-ordinates of the real environment from their consciousness'.[23]

In *New Originals*, works of art are materially present and are simultaneously created on an immaterial level in the imagination. The unstable, intermediate zone cited by Barthes is accordingly explored in an individual manner. It is as if the participants in *New Originals* could abandon the position of the observer and become part of the reality of the picture. *New Originals* places the participants in front of the works of art as

actual material givens but, in a construction of spaces, texts and noises, it simultaneously demands and facilitates a special approach to the pictures – an assimilation and transformation of them which makes it possible to transcend a superficial, static perception of such givens and to experience reality as an open process.

1 The theme of Speculative Realism was first focused on at the conference 'Speculative Realism' at Goldsmiths, University of London in 2007; it arises out of Correlationism, which was named by the philosopher Quentin Meillassoux.

2 Deutschlandfunk <http://www.deutschlandfunk.de/spekulativer-realismus-ueber-eine-neue-art-auf-der-erde-zu.1184.de.html?dram:article_id=346024> accessed 22.12.2016.

3 Kunstmuseum Bonn, Vom Rheinischen Expressionismus bis zur Kunst der Gegenwart (Bonn, 2012), pp. 9, 10.

4 Garcia, Dora, *451 The Mnemosyne Revolution*, newspaper for the exhibition *An Imagined Museum – Works from the Centre Pompidou, Tate and MMK Collections*, Museum für Moderne Kunst, Frankfurt a.M., Centre Pompidou, Metz, Tate Liverpool, 2016.

5 Berger, John, *Sehen – Das Bild der Welt in der Bilderwelt* (1974), p. 10.

6 'The way we see things is affected by what we know or what we believe.' Ibid., p. 8.

7 Grigely, Joseph, 'Soundscaping', in *Artforum*, Autumn 2016, p. 251.

8 Ibid., p. 260.

9 Banai, Nuit, 'Yves Kleins Abenteuer der Leere', in *Yves Klein*, ed. Oliver Berggruen, Max Hollein, Ingrid Pfeiffer, exhib. cat. Schirn Kunsthalle Frankfurt (Ostfildern-Ruit, 2004), p. 22.

10 Monitor BBC, 1961 Max Ernst <https://www.youtube.com/watch?v=6a6cw3Lgw94> accessed 31.12.2016.

11 <http://www.aec.at/about/geschichte/> accessed 21.11.2016.

12 Mitteilungen und Berichte aus dem Institut für Museumskunde, No. 23, audio-guided tours in museums and exhibitions, report of the symposium at the Filmmuseum Berlin, 2001.

13 Ibid., p. 8.

14 <http://johncage.org/pp/John-Cage-Work-Detail.cfm?work_ID=100> accessed 20.12.2016.

15 <http://cardiffmiller.com/artworks/walks/missing_voice.html#> accessed 20.12 2016.

16 Feldhoff, Silke, 'Zwischen Spiel und Politik. Partizipation als Strategie und Praxis in der bildenden Kunst' (2009), p. 7 <https://opus4.kobv.de/opus4-udk/files/26/Feldhoff_Silke.pdf> accessed 12.10.2016.

17 Glauner, Max, 'Get Involved! Partizipation als künstlerische Strategie', in *Kunstforum* No. 240, *Get involved!* p. 31.

18 Ibid., p. 28.

19 http://www.monopol-magazin.de/google-und-facebook-wollendass-wir-ihre-welt-nicht-mehr-verlassen (accessed 20.12.2016).

20 Liptay, Fabienne, 'Neither Here nor There, The Paradoxes of Immersion', in Liptay, Fabienne, and Burcu Dogramaci (eds.), *Immersion in the Visual Arts and Media* (Leiden/Boston, 2015), p. 87. (Original quotation translated by Stefan Barmann.)

21 Barthes, Roland, 'En sortant du cinéma', in Communications, 23, (1975), p.104-107, quoted after: Liptay 2015 (like footnote 20), p. 87. (Translation by Stefan Barmann.)

22 Quoted according to ibid. (Translation by Stefan Barmann.)

23 Ibid. (Translation by Stefan Barmann.)

sublimi feriam sidera vertice

Ronald Jones

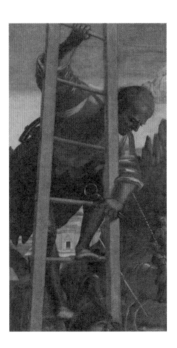

Luca Signorelli, *Mann auf einer Leiter*, 1504/05
Luca Signorelli, *Man on a Ladder* © The National Gallery, London.
Accepted by HM Government in lieu of Inheritance Tax and allocated
to the National Gallery, 2016

Sei nicht in Angst! Die Insel ist voll Lärm,
Voll Tön' und süßer Lieder, die ergötzen
Und niemand Schaden tun. Mir klimpern manchmal
Viel tausend helle Instrument' ums Ohr,
Und manchmal Stimmen, die mich, wenn ich auch
Nach langem Schlaf erst eben aufgewacht,
Zum Schlafen wieder bringen: dann im Traume
War mir, als täten sich die Wolken auf
Und zeigten Schätze, die auf mich herab
Sich schütten wollten, daß ich beim Erwachen
Aufs neu' zu träumen heulte."

William Shakespeare, *Der Sturm*, 3. Aufzug, 2. Szene[1]

I

Von Zeit zu Zeit, wenn ich einem Kunstwerk nachspüre, flüstert die Poesie. Gestern wieder geschah es, als ich durch die National Gallery in London streifte. Der jüngste Neuzugang, Luca Signorellis *Mann auf einer Leiter* von 1504/05, nahm mein *Ohr* gefangen.

Die Tafel, eines von sechs bekannten Fragmenten des großen Altarbildes mit der *Beweinung*, wurde 1504 für die Kirche Sant'Agostino in Matelica in Auftrag gegeben. Letztlich wurde der Altar in Teile zerlegt, die man abschätzig als „Memento-Mori-Fragmente" bezeichnen würde. Sir William Graham war der erste Besitzer dieser Tafel, er hat sie in Wahrheit aber nie anders denn als Trophäe gewürdigt und letztlich wiederum an den Präraffaeliten Sir Edward Burne-Jones entliehen. Für Graham war dies eine Geste des Respekts gegenüber der Verehrung, die Burne-Jones für Signorellis Werk hegte.

So eindeutig der Titel des Fragments, so schillernd ist seine Uneindeutigkeit. Denn es stellt zwar gewiss einen Mann auf einer Leiter dar, doch wie sich erweist, ist es nicht irgendeine Leiter, sondern wohl diejenige, die Christi Henker an das Kreuz lehnten, wenngleich dies aus der Anschauung des Fragments allein kaum ersichtlich ist. Dieser Mann, ein wenig grobschlächtig oder, milder ausgedrückt, ein „Henker von Profession", balanciert mit einem Zutrauen auf einer Sprosse, das nur aus großer Übung erwachsen sein kann. In einer Hand hält er eine Zange und entfacht damit unsere Vorstellungskraft – hat er soeben drei, vielleicht vier Nägel aus blutigem Holz und Fleisch gezo-

gen? Longinus, der römische Zenturio, der Jesus bekanntlich in die Flanke stach, ist nirgends zu sehen, und ich erwähne ihn hier, weil er uns von den Henkern als Einziger namentlich überliefert ist. Unser anonymer Mann mit Zange ist keine „historische Figur", wie sehr er es auch *in Wirklichkeit* sein mag. Betrachten wir das Gesamtgefüge der Bildelemente, aus denen sich die *Beweinung* zusammensetzt, so sehen wir, dass unser professioneller Henker über *seinem Opfer* Christus aufsteigt, das nun am Fuß des Kreuzes liegt, betrauert von der Jungfrau Maria und seinen Jüngern. Am unteren Rand der Tafel, gekrönt mit einem leuchtenden, wenn auch durchscheinenden Nimbus, finden wir Johannes den Täufer. Nachdem das Töten erledigt ist, blickt der berufsmäßige Henker verständlicherweise hinab, um sein Werk zu begutachten, während der Heilige Johannes sublim verzückt gen Himmel schaut – ein visueller Kontrapunkt, den Signorelli ausgekostet haben muss.

Nun, damit scheint die Geschichte erzählt. Doch als ich vor Signorellis Tafel stand, dachte ich an Robert Lowells frühe Hinneigung zum christlichen Erhabenen und an seinen eigenen verwundeten Christus in dem Gedicht *Sublime Feriam Sidera Vertice*, ein Titel, den er zweifelsohne Horaz' erster Ode entlehnt hat, worin der Dichter doppelsinnig verheißt: *Quodsi me lyricis vatibus inseres / sublimi feriam sidera vertice* („Reihst Du mich jedoch unter die lyrischen Dichter / stößt an die Sterne mein erhabenes Haupt"[2]). Von Lowell zu Horaz und über Signorelli wieder zurückschweifend, glitten meine Gedanken sanft von deren subtilen Dramen zu denen von Lundahl & Seitl – und warum? Anfangs war das auch mir nicht klar, doch erkennen wir bei allen fünf gleitende, sich entwickelnde Stile, und sie alle flüstern uns ihre Poesie ins Ohr – und mit welchem Ergebnis? Einmal in den unbestimmten Zustand der Körperlosigkeit versetzt, können auch wir *an die Sterne stoßen*.

II

Als ich an diesem Abend die National Gallery verließ und den Trafalgar Square betrat, kam mir eine frühere Begebenheit in den Sinn, wie ich in meiner Studentenzeit an einer Zeichnung von Philip Guston vobeigekommen war, die in meinen Gedanken Zeilen von Stanley Kunitz heraufbeschwor. Damals war mein instinktiver Sinn für das wechselseitige Echo von Kunst und Poesie ausgeprägter, als ich selbst es hätte verstehen können …, und nur wenig später kam ich darauf, dass Guston in

seiner Werkreihe *Poem Pictures* oft Kunitz zitierte, darunter dessen Gedicht „King of the River" von 1970.

> „Ein Trockenfeuer frisst dich auf.
> Fett tropft von deinen Knochen.
> Die Rillen deiner Rippen verbleichen.
> Du bist zu einem Schiff geworden für Parasiten.
> Die große Uhr deines Lebens
> gerät ins Stocken,
> und die kleinen Uhren drehen durch.
> Dafür wurdest du geboren.
> Du hast in den Wind geheult
> und hörtest die Antwort des Windes:
> ‚Nicht ich wählte den Weg,
> der Weg wählte mich.'" [3]

Wahre Dichtung. Mit diesen Zeilen von Kunitz im Kopf bedarf es wohl keiner großen Einbildungskraft, um sich auszumalen, wie Signorellis Christus eben diese Verse vom Kreuz zu uns herabruft. „Die große Uhr deines Lebens gerät ins Stocken ... Nicht ich wählte den Weg, der Weg wählte mich", ein autobiografischer Psalm aus dem Stegreif darüber, wie oft Umstände über ein Schicksal entscheiden. Ich bringe diese ganze historische Resonanz zwischen Dichtung und Kunst von Signorelli bis Guston deshalb auf, um eine Tür zur Betrachtung von Lundahl & Seitls Werk als verkörperte „Gedichtbilder" zu öffnen, verankert durch die Zeilen aus Shakespeares *Sturm*, die ich für diesen Essay als Auftakt in Dienst genommen habe. Christer und Martinas Werk belegt uns, wenn wir die „Insel voll Lärm" betreten, mit einem geheimnisvollen Zauber. Ebenso beruht das Shakespeare spiegelnde Erlebnis, das die beiden gestalten, entscheidend auf der Stimme, die uns ins Ohr flüstert und imaginäre Szenenbilder heraufbeschwört: „Mir klimpern manchmal viel tausend helle Instrument' ums Ohr, und manchmal Stimmen ..."

Freilich gab es Zeiten, in denen Poesie und Kunst einander gar nicht so fern waren, wie sie es uns heute scheinen; Gustons Kunst ist dafür nur ein Beispiel auf modernem Gebiet. Natürlich gibt es noch Jasper Johns' *Skin with O'Hara Poem* von 1963/1965 und Weiteres. Aber auch Robert Wilsons Lyrik zu der Musik von Phillip Glass – ich könnte fortfahren. Noch weiter zurück in der Zeit, vor siebenundsechzig Jahren, veröffentlichte Rensselaer W. Lee seinen bahnbrechenden Text *Ut Pictura Poesis, The Humanistic Theory of Painting*, den Sie, falls Sie ihn noch nicht kennen, lesen sollten, ehe sie mit meinem Text fortfahren. Während der Renaissance waren Dichtung und Malerei die „Schwesterkünste". Lee versichert uns dessen fachmännisch mit seiner tadellosen Gelehrsamkeit. Und Christer und Martina zeigen uns, dass dies abermals gilt. Folgen Sie Lees Worten und schauen Sie, ob Sie mir sagen können, warum diese nicht ohne Weiteres auf Lundahl & Seitls Kunst anwendbar sein sollten. „Die Schwesterkünste", so Lee, „wie sie allgemein hießen – und Lomazzo merkt an, dass sie in einem Schwung geboren wurden –, unterschieden sich anerkanntermaßen in Mitteln und Manier des Ausdrucks, galten jedoch ihrer Grundnatur, ihrem Inhalt und ihrem Zweck nach als nahezu identisch." Der Hauptunterschied zwischen Lees Einsicht beziehungsweise seiner Betonung der Visualität – buchstäblich die halbe Miete – und der Weise, wie Christer und Martina ihre Kunst inszenieren, besteht darin, dass Ihr Erleben eines Werks von Lundahl & Seitl gänzlich in Ihrem geistigen Auge, Ihrer Imagination stattfindet, gerade weil Ihr Sehvermögen hinter den opaken Masken strategisch Ihrer Einsicht überlassen wird. Und zwar während Sie buchstäblich durch „realen" Raum geführt werden, der insofern wenig Wirkung zeigt als, sobald Sie die Brille aufgesetzt haben, Ihre Imagination der Ort ist, *wo Sie sind*.

Ich habe mich oft gefragt, wie das Erlebnis eines Werks von Lundahl & Seitl für eine von Geburt an blinde Person wäre. Und ich habe oft in Erwägung gezogen, dass ein solches, etwa *New Originals* im Kunstmuseum Bonn, für eine sehende Person womöglich zeitweilig in eine Erfahrung dessen übergehen könnte, was die Theologen als *religiöse Ekstase* bezeichnen. Religiöse Ekstase, Euphorie oder Visionen werden ausgelöst, sagen uns die Theologen, sobald ein veränderter Bewusstseinszustand dadurch entsteht, dass wir unsere äußere Wachsamkeit einschränken, um unsere innere mentale und spirituelle Wachsamkeit zu erweitern oder zu steigern. Und wo ist der Unterschied zwischen diesem Phänomen und einer Performance von Lundahl & Seitl oder auch den historischen Aussagen darüber, wie Kunst oder die natürliche Welt eine Epiphanie hervorzubringen vermögen?

Goethes Bericht über sein eigenes Erlebnis des Jungfrau-Gletschers kommt einem in den Sinn. Weiter oben erinnerte ich an die Zeiten, als Dichtung und Kunst einander gar nicht so fern waren, wie sie es uns heute scheinen; aber natürlich besteht

die Kraft eines Werks von Lundahl & Seitl im Kern darin, dass diese sich durch das *Ineinander*-Übergehen von Kunst- und Naturerleben, wenn nicht gar der Traumwelt, auf das philosophische Terrain von Goethes Jungfrau-Erlebnis begeben. Und um alles dies im rechten Maßstab zu sehen: Erreicht haben sie das nur 28 Jahre nach der bahnbrechenden Veröffentlichung des Buches *Simulations*, in dem Jean Baudrillard vollkommen zu recht unsagbar deutlich machte, dass der signifikante Teil der „postmodernen Erfahrung" in der dritten Person stattfand, und anhand einer ganzen Reihe von Beispielen überzeugend nachwies, dass das simulierte Erleben nicht nur zu einer akzeptablen, ja nominalen Realitätsebene, sondern auch *authentisch* wird, indem es unser „In-Berührung"-Sein mit dem Erleben in der ersten Person praktisch verdrängt hat. Lundahl & Seitl haben hinsichtlich des *Baudrillard'schen Simulationismus* das Blatt gewendet. Doch wie?

Sie sind, sagen wir einstweilen, post-baudrillardsch in einem verwandten Sinne, so wie die Bezeichnung Post-Impressionisten verrät, dass frühere Kunsthistoriker zwar benennen konnten, wann diese Künstler in der Geschichte auftraten – nach den Impressionisten –, aber nicht genügend Erfahrung mit deren Schaffen, geschweige denn den historischen Abstand hatten, um in geeigneter Begriffsbildung mehr sagen zu können als *was diese nicht waren*. Ähnlich steht es mit Lundahl & Seitl: Wir wissen, wo sie in der Geschichte hervorgetreten sind, doch um hinsichtlich einer übergeordneten Bedeutung ihrer künstlerischen Praktik mehr sagen zu können als was sie nicht sind, ist es noch zu früh. Und so kann man nicht mehr tun als Bertolt Brecht beizupflichten, der einst sagte: „Eben weil die Dinge so sind, wie sie sind, werden die Dinge nicht so bleiben, wie sie sind." Nachdem ich ein paar „Episoden", wie ich sie gern nenne, von Lundahl & Seitl erlebt habe, kann ich sagen, dass sie die Bedeutung der Erfahrung in der ersten Person innerhalb der Post-Baudrillard'schen Phase wiederhergestellt haben, und zwar ironischerweise, indem sie zu den Theaterkünsten zurückkehrten, und wenn sich dies widersprüchlich anhört, so ist es das jedenfalls im historischen Sinne.

Oft werden Christer und Martinas Narrative aus der Zeugenperspektive erzählt, in dem Sinne, in welchem das Sujet von Luca Signorellis *Mann auf einer Leiter* ein Zeuge war und maßgeblicher noch ein Zeuge, *dem man als dem Zeugen, der er ist, auch vertrauen kann*. Welch seltener Umstand. Oder zumindest sel-

ten im Zeitalter Baudrillards. Was meine ich damit? Lassen Sie mich daran erinnern, dass das *Oxford Dictionary* „post-truth" („postfaktisch") zum Wort des Jahres 2016 ernannt hat und die *New York Times* Donald Trumps Wahl durch das amerikanische Volk regelmäßig als „Post-Truth Presidency" bezeichnet. Lassen Sie sich das kurz durch den Kopf gehen. Mit äußerster Ironie darf ich somit behaupten, dass Christer und Martinas Kunst das glatte Gegenteil des „postfaktischen" Zeitalters repräsentiert. Ist nicht das die wesentliche Kraft ihrer Kunst? Vom Rest der Realität abgeschnitten, sind allein Sie Zeuge, wenn unerwarteterweise durch das Flüstern der Stimme in Ihrem Ohr die Realität, die Wahrheit – nennen Sie es, wie Sie wollen – gesteigert wird, denn natürlich müssen Sie der Stimme trauen wie sich selbst. Falls Baudrillard mit seinen Mutmaßungen über unsere Zukunft im Großen und Ganzen richtig lag, dann sind im Post-Baudrillard'schen Zwischenspiel, in dem ein *akzeptables Realitätsniveau* herrscht, *Sie allein* der Zeuge, der über die Wahrheit urteilt, in die Sie das höchste Maß an Vertrauen setzen müssen. Ich glaube unterdessen, dass dies alles ist, was sich von Christer und Martina mitnehmen lässt, und es ist mehr, als sich irgendwer je hat hoffen können.

„Sobald du dir vertraust, sobald weißt du zu leben."
Johann Wolfgang von Goethe, *Faust* I, Studierzimmer

Poesie flüstert.

Anmerkungen des Übersetzers/der Übersetzerin:

1 In der Übersetzung von August Wilhelm Schlegel (Erstdruck 1798).
2 Übersetzung Stefan Barmann unter Verwendung verschiedener Quellen.
3 Übersetzung Stefan Barmann. Das Original in voller Länge findet sich unter http://www.theatlantic.com/past/docs/unbound/poetry/antholog/kunitz/river.htm.

B e not afeard. The isle is full of noises,
Sounds and sweet airs that give delight and hurt not.
Sometimes a thousand twangling instruments
Will hum about mine ears, and sometime voices
That, if I then had waked after long sleep,
Will make me sleep again; and then, in dreaming,
The clouds methought would open, and show riches
Ready to drop upon me, that when I waked,
I cried to dream again.

William Shakespeare, *The Tempest* 3.2.148-156

I

From time to time, as I saunter past a work of art, poetry whispers. Yesterday it happened again, when I was strolling through the National Gallery in London. The Gallery's fresh acquisition, Luca Signorelli's *Man on a Ladder* from 1504–5, caught my *ear*.

The panel, one of six known fragments of the large altarpiece titled *Lamentation at the Foot of the Cross*, was commissioned in 1504 for the Church of Sant'Agostino, in Matelica. Eventually, the altarpiece was carved up into what one would describe, disagreeably, as 'memento mori fragments'. Sir William Graham was the first to own this Signorelli panel, but truth be known, he never genuinely appreciated it other than as a trophy, and in turn he lent it to the Pre-Raphaelite Sir Edward Burne-Jones. For Graham, this was a gesture of respect, given Burne-Jones' devotion to the work of Signorelli.

For such an unequivocal title, this fragment shimmers with ambiguity. For while it certainly does depict a man on a ladder, as it turns out it is not just any ladder but rather the one that Christ's executioners leaned against his cross, although that is hardly obvious from looking at the fragment alone. This man, a bit of rough-trade, or in more charitable terms a 'tradesman-executioner', balances on a rung with a confidence that could only come with great practice. He grips a nail pincer, triggering our imagination – has he just pried three, or perhaps four, nails from bloodied wood and flesh? Longinus, the Roman Centurion who famously pierced Jesus' side, is nowhere to be seen, and I bring him up now because his name is the only one we have of the executioners. Our anonymous man with pincer

is not a 'historical figure', however much he *really is*. Reading the measure of the full ensemble of imagery composing the *Lamentation at the Foot of the Cross*, we see that our tradesman-executioner is ascendant over Christ, *his victim*, who now lies at the foot of his cross, mourned by the Virgin Mary and His followers. At the bottom of this panel, crowned with a resplendent, if translucent, halo, we find St. John the Evangelist. With the killing done, our tradesman-executioner understandably stares down, inspecting his work, while St. John's gaze is sublimely transfixed on Heaven: a visual counterpoint Signorelli must have savoured.

Well, that seems to tell the story, but standing before Signorelli's panel, I thought back to Robert Lowell's early infatuation with the Christian sublime and his own wounded Christ in *Sublime Feriam Sidera Vertice*, a title he has undoubtedly borrowed from Horace's first ode where the poet ambitiously promises *Quodsi me lyricis vatibus inseres/sublimi feriam sidera vertice* ('But if you should place me among the lyric poets/I will strike the stars with my lofty top'). Running from Lowell to Horace, and back again through Signorelli, my mind gently shifted from their subtle dramas towards those of Lundahl & Seitl – but why? At first it wasn't clear even to me, but in the case of all five, we are able to trace shifting and evolving styles, all whispering their poetry into our ears – and as a result? Once transported into the imprecise state of incorporeality, we too may *strike at the stars*.

II

That same evening, as I left the National Gallery and stepped out into Trafalgar Square, an earlier occasion came to mind: when, as an undergraduate, I had passed a Philip Guston drawing that triggered in my mind lines by Stanley Kunitz. Back then, my instinct for the reciprocal echoing between art and poetry was more explicit than I could have understood… and it was only a little later I discovered that, indeed, in Guston's series of *Poem Pictures*, the painter often quoted Kunitz, including this 1970 poem 'King of the River'.

A dry fire eats you.
Fat drips from your bones.
The flutes of your gills discolor.
You have become a ship for parasites.
The great clock of your life

is slowing down,
and the small clocks run wild.
For this you were born.
You have cried to the wind
and heard the wind's reply:
"I did not choose the way,
the way chose me."

Poetry indeed. With these lines from Kunitz in mind, it takes no great leap of the imagination to envision Signorelli's Christ calling down these very verses to us from his cross… 'The great clock of your life/is slowing down […] I did not choose the way,/the way chose me': an impromptu autobiographical psalm about how often circumstances decide your destiny. I raise all of this historical resonance between poetry and art, from Signorelli to Guston, to open the door to contemplating Lundahl & Seitl's work as embodied 'poem pictures', anchored by those lines from *The Tempest* that I put into service as the prelude to this essay. With Christer and Martina's work, a mysterious spell is cast as you enter the *isle full of noises*. And likewise, mirroring Shakespeare, the experience they compose crucially relies on the voice whispering in your ear, triggering imaginary scenes: 'Sometimes a thousand twangling instruments/Will hum about mine ears, and sometime voices…'

Of course, there were times when poetry and art were hardly as distant from one another as they seem to us now; Guston's art is only a single example in the modern setting. There is, of course, Jasper Johns' *Skin with O'Hara Poem*, 1963/1965, and others still. Robert Wilson's lyric to Philip Glass' music; I could go on. Farther back in time, seventy-six years ago, Rensselaer W. Lee published his watershed text *Ut Pictura Poesis: The Humanistic Theory of Painting* (if you've neglected to read this, you should, before going on with my text). During the Renaissance, poetry and painting were the 'sister arts'. Lee expertly assures us of this with his flawless scholarship. And Christer and Martina show us that this is true once again. Listen to the words of Lee, and then see if you can tell me *why they wouldn't comfortably apply* to Lundahl & Seitl's art. 'The sister arts,' Lee wrote, 'as they were generally called – and Lomazzo observes that they arrived at a single birth differed, it was acknowledged, in means and manner of expression, but were considered almost identical in fundamental nature, in content, and in purpose.' The principal difference between Lee's insight or his emphasis

on visuality – literally half of the bargain – and how Christer and Martina stage their art is that your experience of a Lundahl & Seitl work takes place entirely within your mind's eye, your imagination, precisely because your sight is strategically forsaken to your insight, behind their opaque masks. And yes, while you are literally guided through 'real' space, that is of little consequence, because once behind the mask your imagination is *where you are*.

I've often wondered what the experience of a Lundahl & Seitl would be like for a person blind since birth. And I have often contemplated that perhaps a Lundahl & Seitl, like *New Originals* at the Kunstmuseum Bonn, for a sighted person, could potentially cross over at moments into an experience close to what theologians have called *religious ecstasy*. Religious ecstasy, euphoria or visions, are triggered, theologians tell us, once an altered state of consciousness is created by reducing your external awareness in order to expand or enhance your interior mental and spiritual awareness. And where is the difference between this and a Lundahl & Seitl performance – or, for that matter, the historical claims made on behalf of art or the natural world for producing an epiphany.

Goethe's description of his own experience of the Jungfrau glacier comes to mind. Earlier in this essay, I wondered about the times when poetry and art were hardly as distant from one another as they seem to us now, but of course the core strength of a Lundahl & Seitl work is that by blurring the experiences of art and the natural, if not also the dream, world *into one another*, they dwell in the philosophical realm of Goethe's Jungfrau experience. And to put all of this into perspective, they have accomplished this only twenty-eight years since the watershed publication of Jean Baudrillard's *Simulations*, when, and rightfully so, Baudrillard made it unarguably self-evident that the significant part of 'postmodern experience' took place in the third person, demonstrating this with example after example, and convincing us that not only had the simulated experience become an acceptable, even a nominal, level of reality, but it was also *authentic*, all but having displaced our being 'in-touch' with first-person experience. Lundahl & Seitl have turned the tide on *Baudrillardian Simulationism*. But how?

They are, let's say for now, Post-Baudrillardian, in a similar way to the Post-Impressionists' name betraying the fact that

while earlier art historians could name where they appeared in history – after the Impressionists – the historians lacked enough experience with the work, and least of all historical perspective, to have shaped their language to say anything other *than what they were not*. Lundahl & Seitl are similarly situated; we know where they emerged in history, but with regards to an over-reaching meaning for their practice – to say anything more than what they are not – well, it is still too soon to do more than agree with Bertolt Brecht who once said: 'Because things are the way they are, things will not stay the way they are.' Having experienced a number of what I like to call Lundahl & Seitl 'episodes', I can say that they have re-established what experience in the first person means within the Post-Baudrillardian interlude, ironically, by reverting to the theatrical arts; and if that sounds contradictory, it is – at least in the historical sense.

Often Christer and Martina's narratives are told from the perspectives of witnesses, in the sense that the subject of Luca Signorelli's *Man on a Ladder* was a witness, and more significantly a witness *that you may also trust as the witness he is*. How rare. Or, at least, how rare within the Baudrillard-era. What do I mean? Well, let me just recall for you that the Oxford Dictionary named 'post-truth' the word of the year in 2016, and *The New York Times* regularly refers to Donald Trump's election by the American people as a 'Post-Truth Presidency'. Linger over this for a moment. It is with extreme irony that I can claim that Christer and Martina's art represents the very opposite of the 'post-truth' era. Isn't this the essential strength of their art; cut off from the rest of reality, you alone are the witness; when unexpectedly, through the whispering voice in your ear, reality, truth, call it what you will, becomes enhanced, because you must, of course, trust the voice as you trust yourself. If Baudrillard was mostly correct in his assumptions about our future, then in the Post-Baudrillardian interlude, where *an acceptable level of reality* reigns, *you alone* are the witness judging truth, upon which you must place the greatest measure of trust. I have come to believe that this is all there is to take away from Christer and Martina, which is more than anyone could ever have hoped for.

As soon as you trust yourself, you will know how to live.
Johann Wolfgang von Goethe, *Faust* I, Studierzimmer

Poetry whispers.

Epilog · Epilogue
Ein unendlicher Prozess · An Infinite Process

Johan Poussette

D enn die Erinnerung ist kein physisches Ding, sondern eine Manifestation dessen, was wir statt des zu Sehenden sehen möchten. Deshalb wird sie sich stets entsprechend dem Zustand des Betrachters verändern."

Alex Backstrom, *Die Quallenfalle* [1]

Meine erste Begegnung mit dem Künstlerduo Lundahl & Seitl fand in völliger Dunkelheit statt. Sie hatten mir die Sicht genommen, in deren Abwesenheit sich meine übrigen Sinne schärften, bis ich ein *unendliches Gespräch* erlebte, das bis heute fortdauert. Seit ich dieser ersten performativen Installation im Magasin III in Stockholm begegnet bin, haben die beiden mich in jeder neuen Installation dazu gebracht, die gewöhnliche Wahrnehmung der Realität infrage zu stellen zugunsten einer imaginierten Welt, die durchaus realer sein könnte als die reale.

Von Oktober 2016 bis März 2017 haben wir die Freude, dass dieses Künstlerduo im Rahmen des Residenzprogramms Iaspis – Swedish Arts Grants Committee's International Programme for visual and applied artists – des internationalen Programms des schwedischen Stipendienkommitees für Ausübende der bildenden und angewandten Künste – in Stock-

holm unser Gast ist. Ihr Aufenthalt signalisiert eine Rückkehr in die Kunstszene Schwedens und Stockholms nach vielen Jahren in London. Während ihrer Zeit hier haben wir einen Workshop als Teil des „Process in Focus" veranstaltet, einem Format, das innerhalb des Residenzprogramms initiiert wurde, um einer kleinen Gruppe von Berufskünstlerinnen und -künstlern Gelegenheit zum vertieften Gespräch über einen laufenden künstlerischen Prozess zu bieten. In diesem Fall kreiste das Gespräch um die künstlerische Praxis von Lundahl & Seitl und insbesondere um die ortsspezifische Arbeit *New Originals*, die sie derzeit in Zusammenarbeit mit der Kuratorin Sally Müller, die ebenfalls an »Process in Focus" teilgenommen hat, für das Kunstmuseum Bonn entwickeln. Von der Sammlung des Museums ausgehend, reflektiert *New Originals* über Konzepte wie Original/Kopie und fragt, was ein Bild ausmacht, wie Erinnerungen (aus)geformt werden und was dies für die Wahrnehmung bedeutet.

Es war ein Privileg, ihre Arbeit im Iaspis-Atelier zu verfolgen. Ihr künstlerischer Prozess startet ergebnisoffen, mit vielfältigen Assoziationen und Bezügen zu möglichen und unmöglichen Gedanken. Es ist, als begännen sie mit dem ganzen Universum – bis hin zum Licht und zu den Positionen der Planeten! Letztendlich aber wird dieses notwendige Chaos

zu einem Fazit destilliert, einer Form, einer Aussage und vor allem einer Frage. Mit Resultaten, die eher Fragen stellen als versuchen Antworten zu geben, bleibt der Prozess in Gang. Er setzt sich in den jeweiligen Betrachtern und Betrachterinnen fort, und das fertige Werk wird dann Teil eines größeren Werkkomplexes oder vielleicht eines Gesprächs.

In ihrer Bewerbung für das Iaspis-Programm schrieben Lundahl & Seitl zu dem von ihnen vorgeschlagenen Projekt, sie würden gern erforschen, wie Kunst durch die Formen und Kontexte, in denen wir sie erfahren, mit Tradition und Geschichte verknüpft ist. Das Projekt lotet aus, auf welche Art und Weise die Bewahrung eines Kunstwerks durch Betrachter- und Betrachterinnenbeteiligung beeinflusst werden kann. Lässt sich Kunst anhand verschiedener Technologien und physikalischer Illusionen in unfassliche Erfahrung umschreiben und auf diese Weise als Erinnerung in den Körpern der Betrachter und Betrachterinnen erhalten?

Bei einem Atelierbesuch schilderten Christer Lundahl und Martina Seitl, das Werk werde aus einer Bewegung von einem Ausgangsraum über einen Mittelraum in einen Endraum bestehen. Für mich scheinen der erste und letzte austauschbar. Hier wird kein linearer Prozess inszeniert, sondern ein zirkulärer. Gleich wo wir beginnen, es geschieht im mittleren Raum – gerade so wie der Akt des Zeichnens negativen Raum hervorbringt, der die Form festlegt. John Bergers Gedanken über *Ways of Seeing* (dt. *Sehen. Das Bild der Welt in der Bilderwelt*) sind für das Künstlerduo eine Referenz.

Das fertige Werk wird eine Verschiebung in Zeit und Erinnerung hervorrufen: Das Bild, das wir am Anfang der Reise erleben, hat sich an ihrem Ende verändert – oder etwa nicht? Hat sich unsere individuelle Erinnerung des Bildes einmal gewandelt, kann sie das Original dann noch repräsentieren oder ist sie zu einem anderen Bild geworden? Können wir eigentlich

von „unserem eigenen" Bild des Bildes sprechen, wenn der Vorgang des Erinnerns durch den Kontext beeinflusst wird, in dem er sich vollzieht? Und was genau ist das Original – existiert es überhaupt oder tun sich für jeden Betrachter, jede Betrachterin neue Originale auf?

Ich selbst erinnere mich lebhaft an ein Kunstwerk, das ich nie gesehen habe, mir aber beschreiben ließ. Interessanterweise stellt das Werk genau diese Frage der Erinnerungsrepräsentation dar. Die Videoarbeit *No Show* des niederländischen Künstlers Melvin Moti von 2004 nimmt sich der wahren Geschichte eines Museumsführers an, der während des Zweiten Weltkrieges mit einer Gruppe russischer Soldaten einen Rundgang durch die geräumte Eremitage in Sankt Petersburg machte. Vor jedem leeren Bilderrahmen schildert der Führer seine Erinnerungen an die Werke und vermittelt hierin die Bilder als subjektive Projektionen vergangener Begegnungen, die dann durch die Einbildungskraft des Publikums zu neuen Bildern werden.

Dora García schreibt über ihre Beziehung zu Kunstwerken: „Du hast sie eingespeichert, in dein Gedächtnis übertragen. Du besitzt die Werke, sie sind nun dein. Du hast dich in ein Museum der Erinnerung verwandelt. Jetzt musst du dich in die Kunstwerke verwandeln. Das ist die Revolution der Mnemosyne. Andere werden zuhören, werden sie wiederum beschreiben, sie einspeichern und sie deshalb *ad infinitum* vervielfältigen, wobei mit jeder Übertragung jedes Kunstwerk neu geschaffen wird und sich für immer ausdehnt wie der Staub ferner Sterne, wie erregende Supernovas."[2]

1 Eine Kurzgeschichte, geschrieben für das Kunstwerk und die Ausstellung *New Originals* von Lundahl & Seitl, 2017.

2 Dora García, *451 The Mnemosyne Revolution*, newspaper for the exhibition *An Imagined Museum – Works from the Centre Pompidou, Tate and MMK collections*, Museum für Moderne Kunst, Frankfurt a.M., Centre Pompidou, Metz, Tate Liverpool, 2016.

For the memory is not a physical thing, but a manifestation of what we want to see rather than what is seen. Therefore it will always change depending on the state of the viewer.

Alex Backstrom, *The Jellyfishtrap* [1]

My first encounter with the artist duo Lundahl & Seitl took place in total darkness. They deprived me of my sight; in its absence, my other senses sharpened into the experience of an *infinite conversation* that continues to this day. Since my experience of this first performative installation at Magasin III in Stockholm, the artists have, with each new installation, made me question the ordinary perception of reality in favour of an imagined world that may well be more real than the 'real' one.

From October 2016 to March 2017, we have the pleasure of hosting this artist duo in Stockholm through the residency programme of Iaspis, the Swedish Arts Grants Committee's International Programme for visual and applied artists. Their stay signals a return to Sweden's, and Stockholm's, art scene after many years in London. During their residency, we held a workshop as part of 'Process in Focus', a format initiated within the residency programme to offer a small group of professionals the opportunity for deeper conversation about ongoing artistic processes. In this case, the conversation centred around Lundahl & Seitl's artistic practice and, specifically, the site-specific work *New Originals*, which they are currently developing for the Kunstmuseum Bonn in collaboration with curator Sally Müller, who also participated in Process in Focus. Drawing on the museum's collection, *New Originals* reflects on concepts such as original vs. copy, what constitutes an image, how memories are formed and what that means in terms of perception.

It has been a privilege to follow the artists' progress in the Iaspis studio. Their artistic process begins in an open-ended manner, with numerous associations and references to possible and impossible thoughts. It is as though they begin with the entire universe – even the light and positions of the planets! But ultimately, this necessary creative chaos is distilled to a conclusion, a form, a statement and, above all, a question. With outcomes that pose questions rather than try to provide answers, the process remains an ongoing one. It continues in

each viewer, and the finished work will be part of a larger body of work, an infinite process, or perhaps a conversation.

In their application to Iaspis, Lundahl & Seitl wrote of their proposed project that they wished to explore how art is connected to tradition and history through the forms and contexts by which we experience it. The project is an exploration of the ways in which the preservation of artwork can be affected by viewer participation. Can art, through various technologies and physical illusions, be transcribed into intangible experience, and in this way be preserved as memory in the body of the viewer?

During a studio visit, Christer Lundahl and Martina Seitl described how the new work would consist of a movement from an initial space to a final space through a middle space. For me, the first and last seem to be interchangeable. This is not a linear process that is being staged, but a circular one. Regardless of where we begin, this middle space is where it happens – just as the act of drawing generates negative space that defines form. John Berger's thoughts on 'Ways of Seeing' is a reference for the artists.

The finished work will produce a shift in time and memory: the picture we experience at the beginning of the journey has changed at its end – or has it? Once our individual memory of the picture has changed, can it still represent the original or has it become another image? Can we even speak of our 'own' picture of the picture, when the process of memory is influenced by the context in which it is created? And what precisely is the original – does it exist at all, or do new originals arise for every viewer?

I myself have a strong memory of a work of art that I have never seen but have had described to me. Interestingly, the work depicts precisely this issue of the representation of memory. The Dutch artist Melvin Moti's video work *No Show*, from 2004, responds to the true story of a museum guide who, during World War II, gave a tour of the vacated Hermitage in St. Petersburg to a group of Russian soldiers. In front of the empty picture frames the guide offers his recollections of the works, conveying the images as subjective projections of past encounters, which then become new images through the audience's imagination.

Dora García writes of her relationship to works of art: 'You have memorised them, transferring them into your memory. You own the works, they are now yours. You have turned yourself into a museum of memory. Now you must turn yourself into the artworks. This is the Mnemosyne revolution. Others will listen, will in turn describe them, will memorize them, and will therefore multiply them *ad infinitum*, each artwork being created anew with each transmission, forever expanding, like the dust of distant stars, like titillating supernovas.'[2]

1 A short story written for the artwork and exhibition *New Originals* by Lundahl & Seitl, 2017.
2 Dora García, *The Mnemosyne Revolution*, 2016.

Lundahl & Seitl
New Originals

im / at the Kunstmuseum Bonn

Original: Paul Adolf Seehaus, *Leuchtturm mit
rotierenden Strahlen*, Öl auf Leinwand / oil on canvas,
1913. Neues Original / New Original: aus der
Erinnerung von / as remembered by Christer
Lundahl, Zeichnung auf
Papier / drawing on paper, 2017.

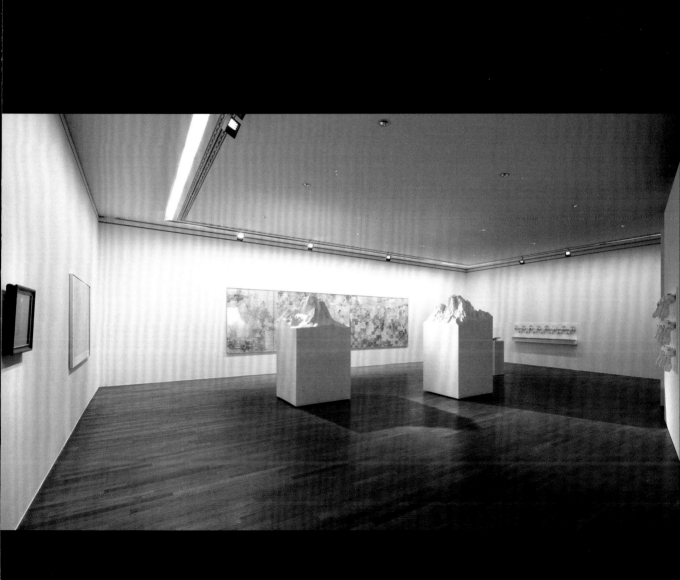

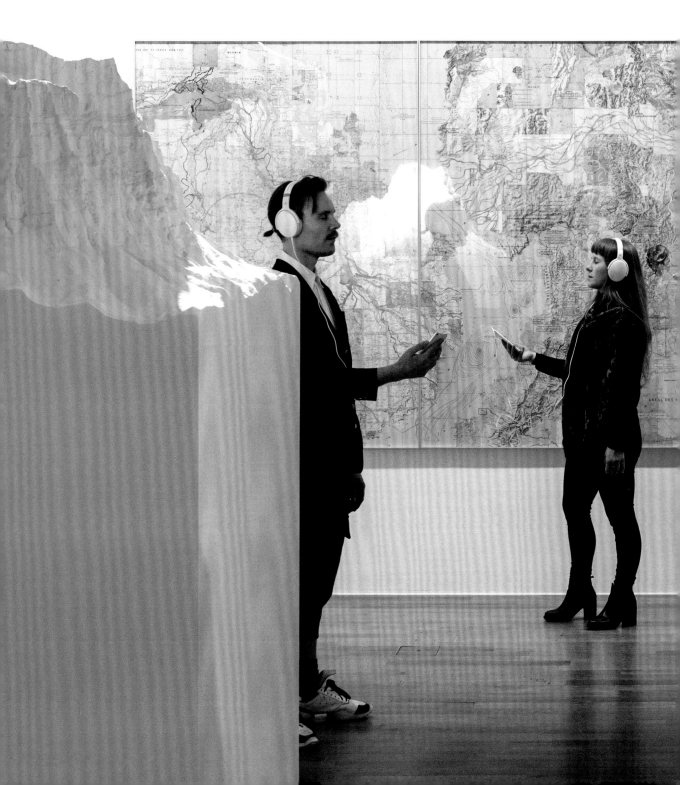

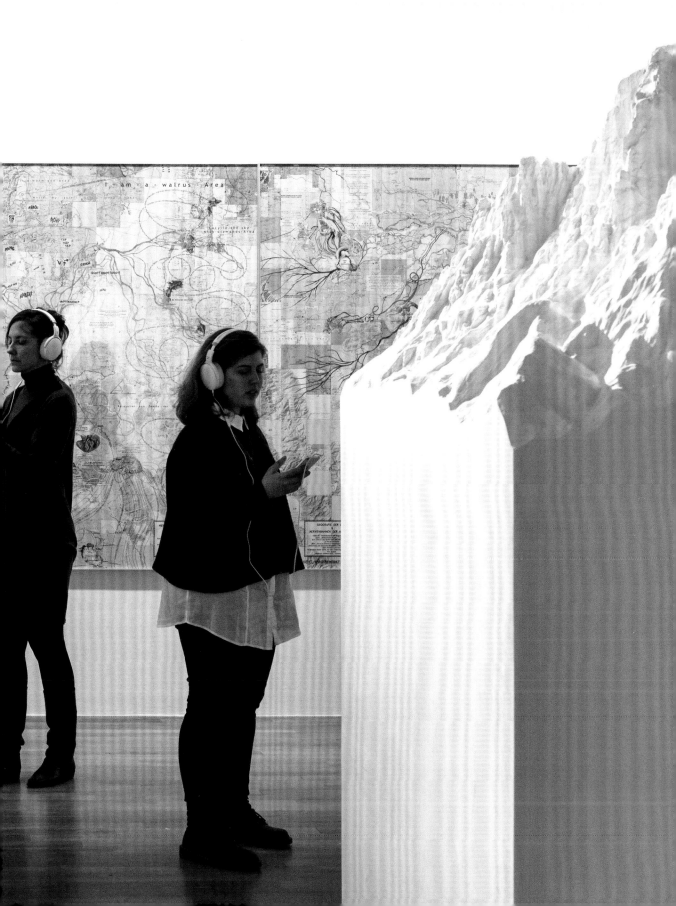

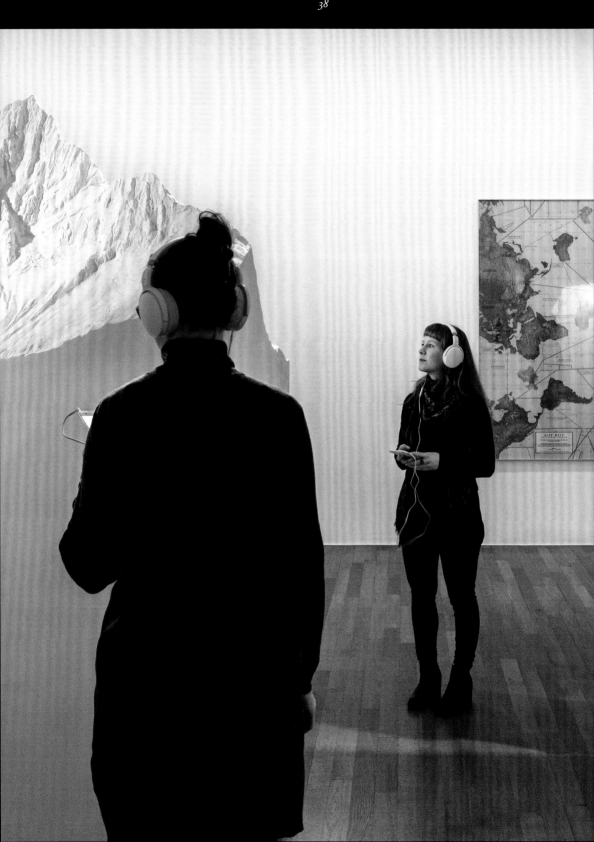

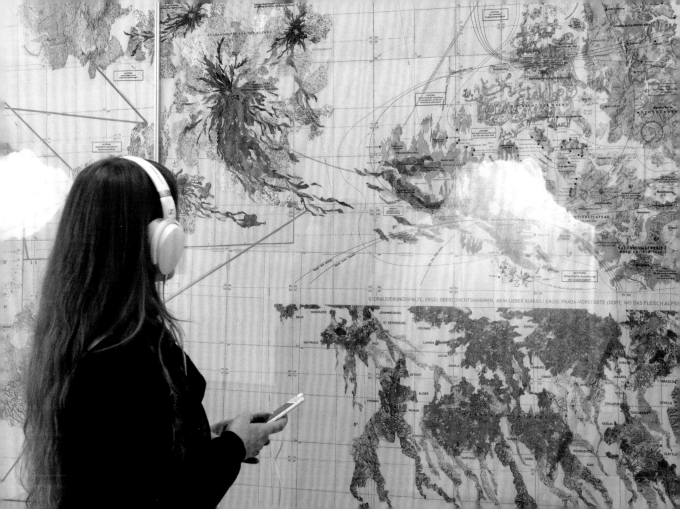

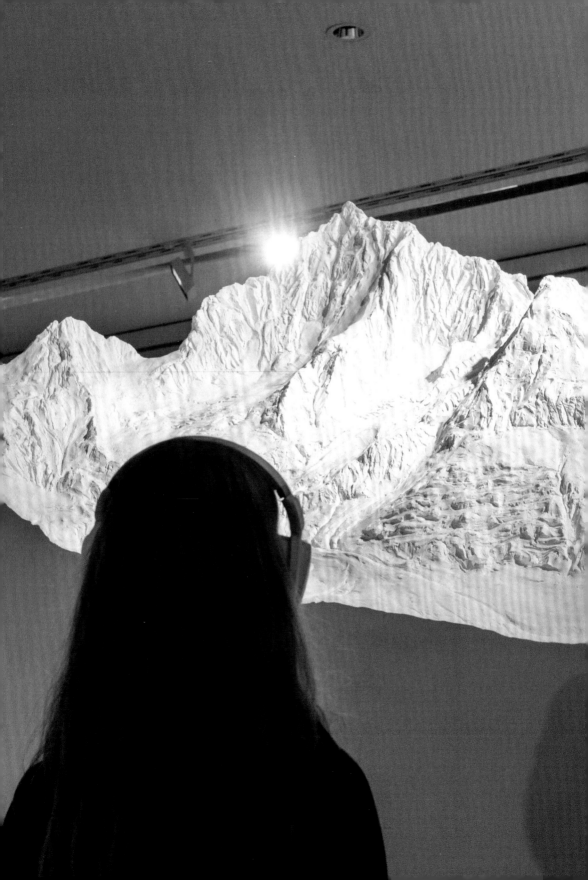

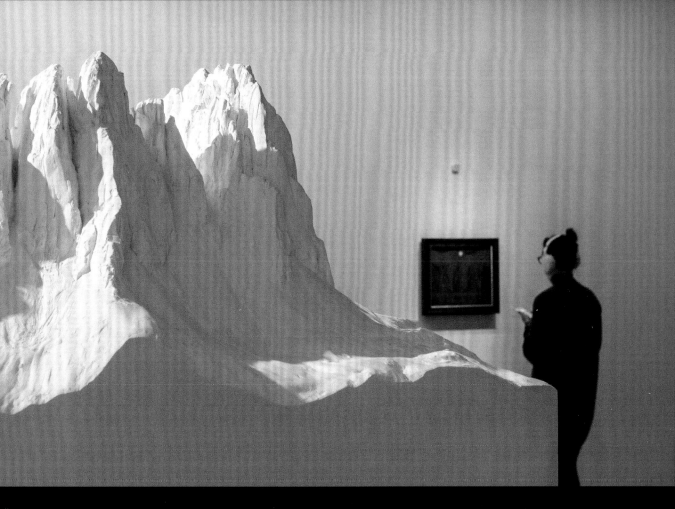

Original: Stephan Huber, *Antelao*, Dentalgips,
Aluminium, Holz, Rigips, Transportrollen / dental cast,
aluminium, wood, plaster board, rollers, 2001. Neues
Original / New Original: aus der Erinnerung
von / as remembered by Christer Lundahl, Zeichnung
auf Papier / drawing on paper, 2017.

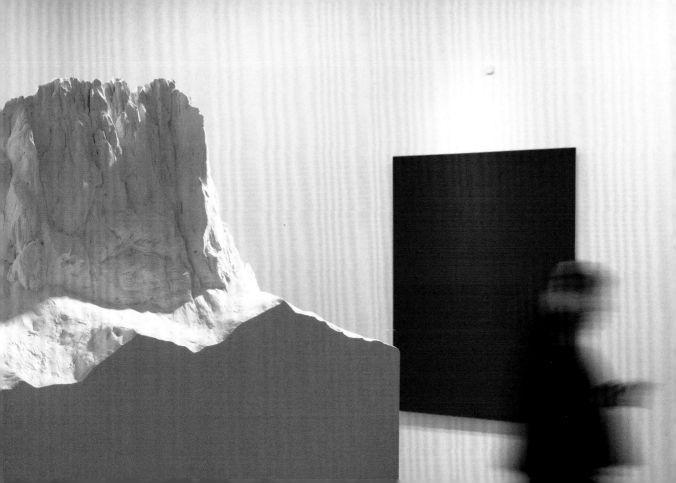

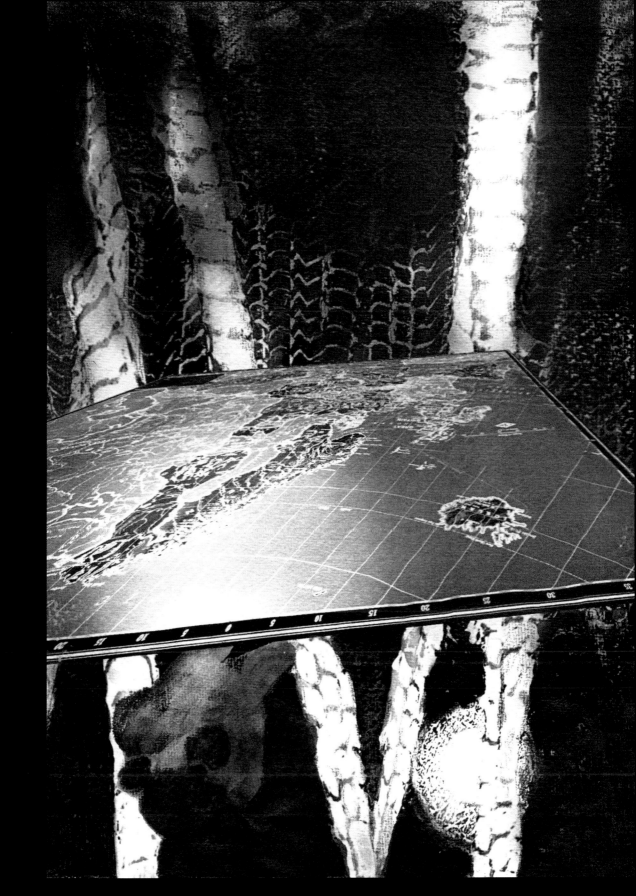

Original: Max Ernst, *La femme 100 têtes*,
Paris, Editions du Carrefour, 20. Dezember /
December 1929. Neues Original / New Original:
aus der Erinnerung von / as remembered by
Christer Lundahl, Zeichnung auf Papier /
drawing on paper, 2017.

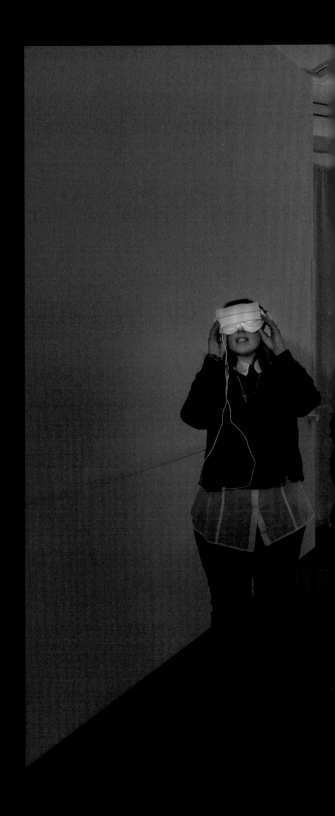

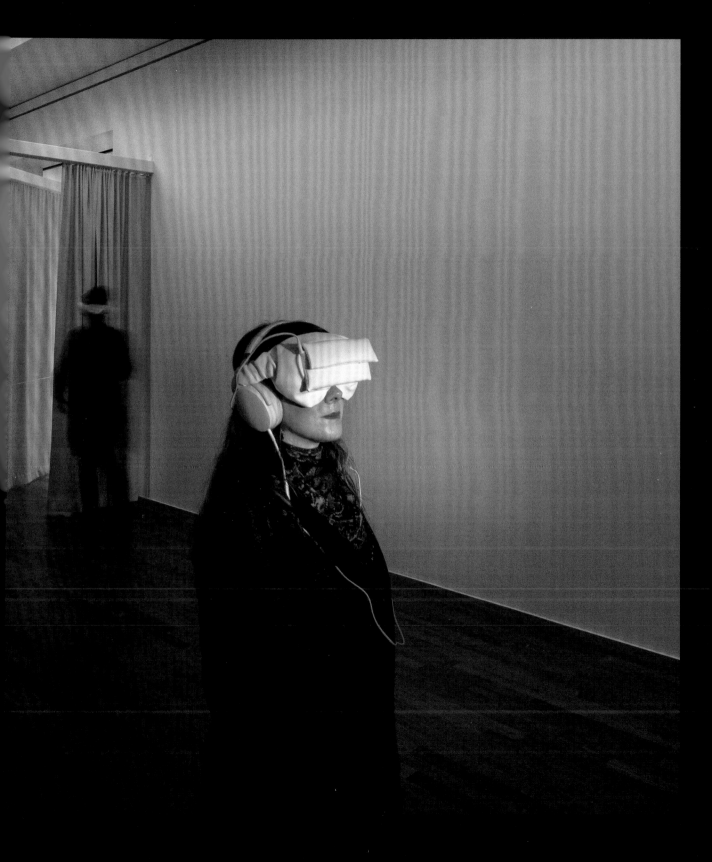

WERKE VON · WORKS FROM

2007 – 2016

I

Das von kollektiver Erinnerung erfüllte Werk *Rotating in a
Room of Images* nimmt den Ausstellungsraum zum Ausgangs-
punkt für die Erschließung von Spuren, die die Kunstgeschich-
te hinterlassen hat. Wie in einem Spuk werden die einzelnen
Besucher und Besucherinnen in dem adaptierbaren Raum von
ihren eigenen Beobachtungen verfolgt. Gleittüren und beweg-
liche Wände leiten sie durch ein Gefüge von Galerieräumen
mit veränderlichen Ausmaßen, in denen sie durch die Zeit ge-
tragen werden. All dies findet in einem dämmrigen Chiaroscu-
ro statt, das schließlich in völlige Dunkelheit übergeht.

In dieser Arbeit geht jeweils ein Teilnehmer oder eine Teil-
nehmerin durch eine Folge von weißgetünchten, neutralen
Ausstellungsräumen. Sie werden in ihren Bewegungen beglei-
tet von einer geisterhaften Erzählung, die sie mittels kabelloser
Kopfhörer vernehmen, sowie von den Bewegungen der sicht-
baren und der versteckten Performer, die sich ebenfalls in dem
Raum befinden. Das Werk gipfelt in einem eigentümlichen,
von den Akteuren aufgeführten Tableau, das durch den Kon-
trast zur unmenschlichen, sterilen Beschaffenheit der voraus-
gegangenen „Szenen" des Werks, aber auch aufgrund seiner
Vertrautheit schockiert – denn mit der Gestalt dieser Szene
(und ihren charakteristischen Figuren) wurden die Besucher
und Besucherinnen im Verlauf der Arbeit bereits auf subtile
Weise bekannt gemacht.

I

Rotating in a Room of Images

Steeped in collective memory, *Rotating in a Room of Images* uses the gallery space as a departure point from which to access traces left by art history. A single visitor is followed by his or her own observations, as if haunted, in a space that is collapsible. Sliding doors and moving walls take the visitor through a sequence of gallery spaces that shift in size and move the visitor through time, all in a faint chiaroscuro that fades to total darkness.

Permitting only one participant at a time, this piece sees the visitor moving through a series of whitewashed and neutral gallery spaces. His or her movements are accompanied by a ghostly narrative conveyed through a wireless headset, along with the movements of both seen and unseen performers who share the space. The work culminates in a strange tableau performed by its actors, shocking both for its contrast to the inhuman and sterilised nature of the work's preceding 'scenes' and also for its familiarity – the shape of this scene (along with its distinctive characters) having been subtly introduced to the visitor throughout the work's duration.

Rotating in a Room of Images, 2007
Installationsansicht / installation view,
Weld, Stockholm, 2007.

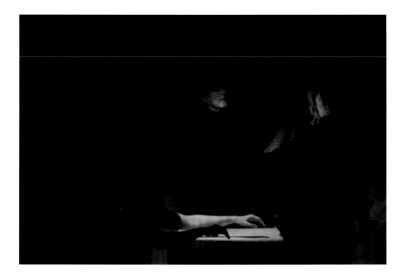

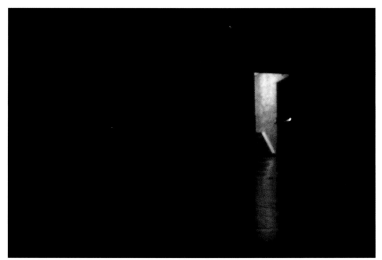

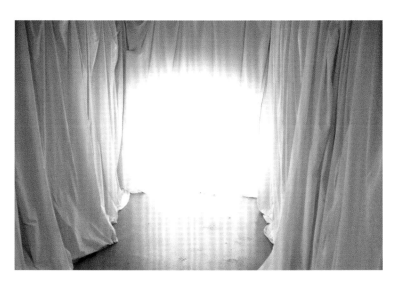

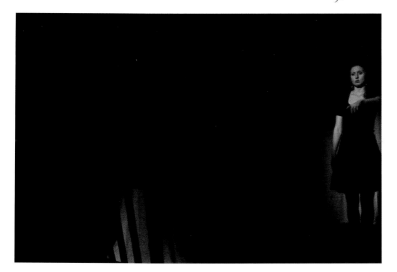

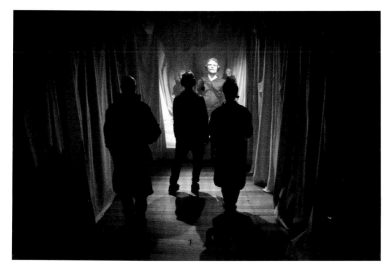

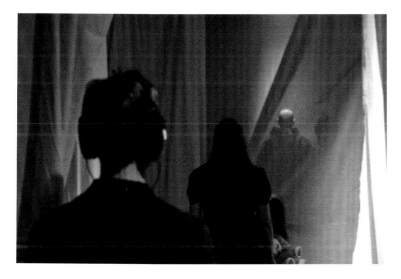

II

Obwohl in völlige Dunkelheit getaucht, weist dieses Werk Ähnlichkeiten mit der minimalistischen Präsentationsweise auf, in der Museen dem Publikum isolierte Objekte zu konzentrierter Betrachtung darbieten: In *Observatory* begeben sich die Besucher und Besucherinnen ganz und gar in eine Situation hinein, in der sie sowohl die Beobachtenden als auch die Beobachteten sind. Die Wahrnehmung selbst ist das Medium des Werks ebenso wie dessen potenzieller Inhalt und auch das Mittel, ihn zu empfangen.

Sechs Besucher und Besucherinnen gleiten in den verdunkelten Ausstellungsraum und erhalten Anweisungen, die ihre Bewegungen zu einer Choreografie koordinieren. Dabei werden sie jeweils individuell angesprochen. Über 60 Minuten hinweg erleben sie ein zeitlich ausgedehntes Ereignis und sehen es aus verschiedenen Perspektiven. Das Erlebnis besteht in dem Innewerden, dass Zeit nicht linear und sequenziell, sondern synchron ist und Vergangenheit, Gegenwart und Zukunft in ihr zusammenhängen. Die Wahrnehmung von Zeit wird erheblich durch die Kultur beeinflusst, ist sie doch kein Objekt, sondern eine Vorstellung und daher subjektiv und offen für Deutung.

Wenn wir uns in *Observatory* befinden, sind wir alle Protagonisten einer ungeschriebenen Geschichte, in der Vorstellungen, körperliche Empfindungen und Erinnerungen zur Aufführung gelangen und auf die ungesehene Bühne hinausprojiziert werden

II

Observatory

Despite being set in complete darkness, this work has a resemblance to the minimalist way in which museums display objects in isolation to attract the focused observation of viewers. In *Observatory*, the visitor is fully immersed in a situation where he or she is both the observer and the observed. Perception itself is the medium of the work: its potential content as well as the means of receiving it.

Six visitors drift inside the darkened gallery. They receive instructions that choreograph their movement in relation to each other. Each visitor is spoken to individually. Over the duration of sixty minutes they experience one event stretched out in time and see it from different perspectives. The experience is a sense that time is not linear and sequential but synchronic; where past, present and future are all interrelated. The perception of time is heavily influenced by culture, since time is an idea, not an object, and therefore is subjective and open to interpretation.

When we are inside *Observatory*, we are all protagonists in a blank story, where imagination, physical sensations and memories are enacted and projected out onto the unseen stage.

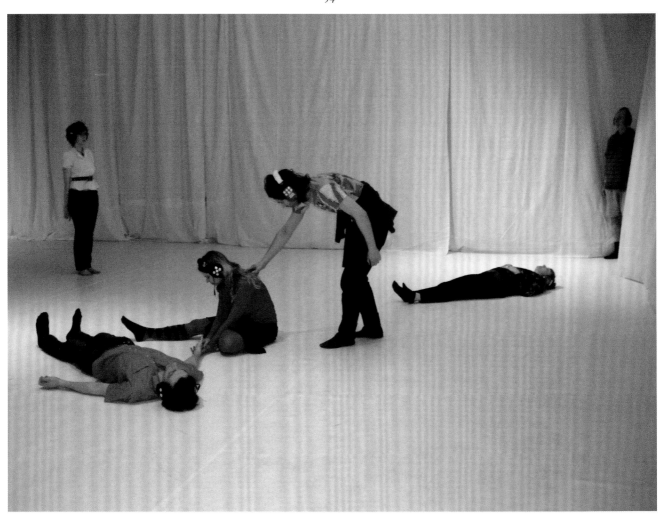

 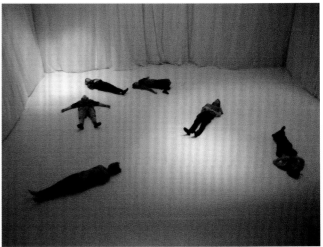

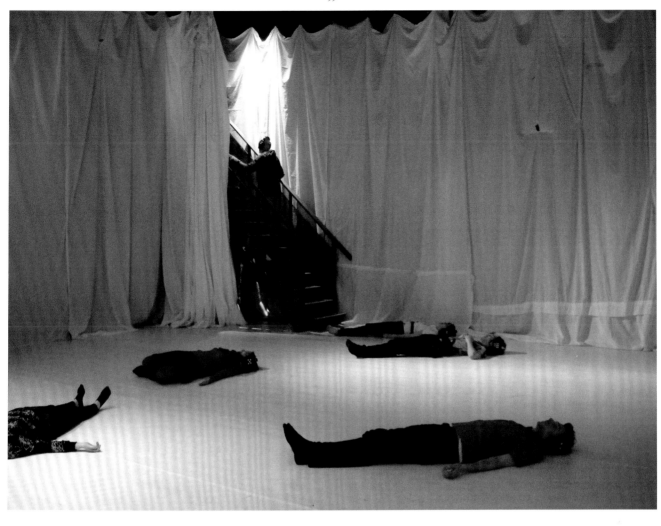

Observatory, 2008
Installationsansicht / installation view,
Weld, Stockholm, 2008.

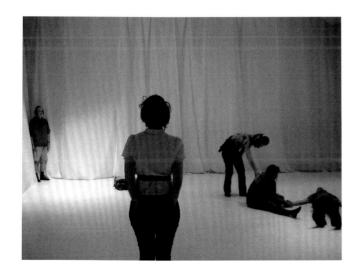
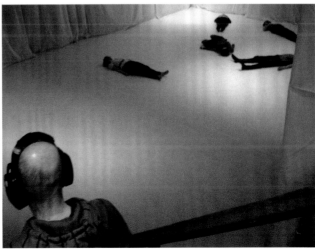

III

In einem abgedunkelten Raum erhellt eine einzelne Lichtquelle zwei über einer Klaviatur schwebende Hände. Unweit davon begeben sich sechs an Flügeln sitzende Personen unter der Führung unsichtbarer Hände auf eine einsame psycho-akustische Reise. Dieses merkwürdige, intime Werk entstand in Zusammenarbeit mit der Experimentalpianistin Cassie Yukawa für den Londoner Verkaufsraum des legendären Klavierherstellers Steinway & Sons. Im Zuge des Stücks wird jeder Zuschauer und jede Zuschauerin zur Hauptfigur, verstrickt in eine synästhetische Erzählung aus Erinnerung, Wahrnehmung und Zeitlosigkeit.

The Memory of W. T. Stead hat sich aus Erkundungen der Struktur von Klang, Haptik, Bewegung und Raum entwickelt. Es bringt die Werke von Johann Sebastian Bach und dem Avantgardisten György Ligeti zusammen – Komponisten, die im Abstand von nahezu 300 Jahren lebten – und spielt auf die parapsychologischen Träumereien des Journalisten W. T. Stead an. Dieser hatte über seinen eigenen dramatischen Tod auf einem Transatlantikliner in Seenot geschrieben, der nicht über genügend Rettungsboote verfügte. Siebenundzwanzig Jahre später ging Stead an Bord der „Titanic" und wurde zum Protagonisten seiner eigenen Geschichte. Die Arbeit entfaltet sich abends in den stimmungsvollen Ausstellungsräumen und Werkstätten des Pianohauses, wenn die Handwerker und Verkäufer nicht mehr anwesend sind und scheinbar nur eine einzelne Pianistin verblieben ist.

III

The Memory of W. T. Stead

In a darkened room, a single light source illuminates a pair of hands poised over the keyboard of a piano. Nearby, six people seated at grand pianos are about to embark on a psycho-acoustic journey, guided by unseen hands. This strange, intimate work was created in collaboration with the experimental pianist Cassie Yukawa for the London showroom of the legendary piano-makers Steinway & Sons and comissioned by Nomad. As the piece unfolds, the viewer becomes the protagonist, immersed in a synaesthetic narrative of memory, perception and timelessness.

The Memory of W. T. Stead evolved from explorations into the structure of sound, feeling, movement and space. It brings together the work of Johann Sebastian Bach and the avant-garde György Ligeti – composers who lived almost 300 years apart – and alludes to the parapsychological musings of W. T. Stead, a journalist who wrote about his own dramatic death on a transatlantic liner which was shipwrecked without enough lifeboats. Twenty-seven years later, Stead boarded the Titanic and became a protagonist in his own story. The work is manifested in the atmospheric piano showroom and workshops in the evening, when the building is bereft of its craftsmen and sales people, and only what seems to be a single pianist remains.

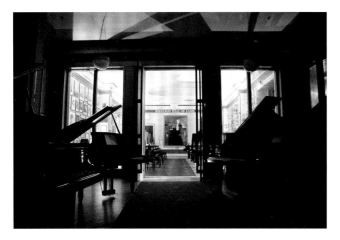

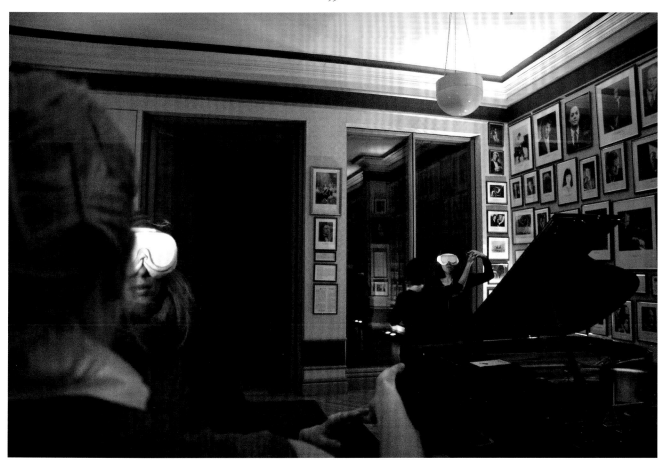

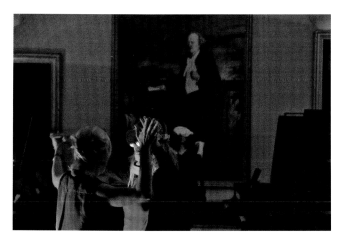
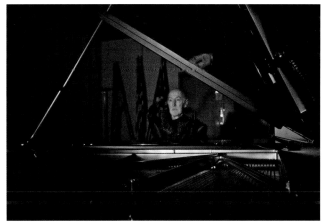

The Memory of W. T. Stead, 2009
Installationsansicht / installation view,
Steinway & Sons piano showroom, London, 2009.

IV

Symphony of a Missing Room untersucht die Phänomenologie der Erinnerung und aktiviert dabei simultan verschiedenste Bedeutungsschichten und Formen des Sehens. Der sicht- und greifbaren Welt durch opake Schneebrillen und kabellose Kopfhörer entrückt, bewegen sich die Besucher und Besucherinnen mithilfe einer Kombination von Audio-Anweisungen und Berührungen ausgebildeter „Führer" durch das Museum.

Wir machen die Erfahrung, von den physischen Begrenzungen in Zeit und Raum befreit zu sein. Wir tun das scheinbar Unvorstellbare, gehen durch Wände und kriechen durch Tunnel, während wir zugleich ein Netzwerk vergangener Ausstellungen bereisen und Museen passieren, in denen *Symphony of a Missing Room* bereits zu erleben war. Unsere Wahrnehmungen sind das einzige Medium in diesem Werk: ein geschlossenes System, in dem die Realität im Grunde als eine Form der Projektion von den Wahrnehmenden ausgeht.

Indem die Arbeit sich auf die Architektur und Geschichte des jeweiligen Museums bezieht, ist *Symphony of a Missing Room* so etwas wie eine Zeitmaschine und erinnert an den Mechanismus von Antikythera, ein 2000 Jahre altes Gerät, das wie *Symphony of a Missing Room* die eigenen vergangenen Verkörperungen aufgenommen hat. So entwickelt die Werkreihe die einzigartige Fähigkeit, sich selbst zu reflektieren, einen inwendigen Blick auf sich festzuhalten – sie ist ein veritables Archiv der Erinnerung.

Zeit und Evolution sind die Schlüsselerfahrungen in diesem seriell angelegten Werk, dessen Premiere 2009 im Schwedischen Nationalmuseum in Stockholm stattfand. Seither war *Symphony of a Missing Room* in zehn international angesehenen Museen zu Gast und wurde überdies zur Kochi-Muziris Biennale in Indien sowie nach Frankreich ins Centre Pompidou-Metz eingeladen.

IV

Symphony of a Missing Room

Symphony of a Missing Room investigates the phenomenology of memory, activating the most diverse layers of meaning and forms of seeing – all simultaneously. Removed from the visible and tangible world by wearing opaque goggles and wireless headphones, visitors move through the museum space aided by a combination of audio instructions and touches from trained 'guides'.

During the experience, we find ourselves freed from the physical limitations of time and space. Doing the seemingly unimaginable, we pass through walls and down tunnels, traveling through a network of past exhibitions and the museums that originally hosted *Symphony of a Missing Room*. Our perceptions are the single medium of the work: a closed system in which reality fundamentally originates from the perceiver as a form of projection.

Existing in parallel with the architecture and history of the host museum, *Symphony of a Missing Room* is akin to a time machine, reminiscent of the Antikythera Mechanism, a 2000-year old machine that, like *Symphony of a Missing Room*, has absorbed its own past incarnations. And so the series of works develops a unique capacity to reflect back on itself, even succeeding in gazing in on itself – indeed a memory archive.

Time and evolution are the key experiences of this serial work, which first appeared at the Swedish National Museum in Stockholm in 2009. It has been hosted by ten internationally renowned museums and future commissions include the Kochi-Muziris Biennale in India and the Centre Pompidou-Metz in France.

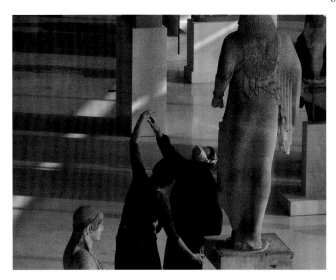
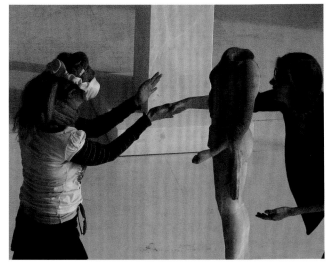
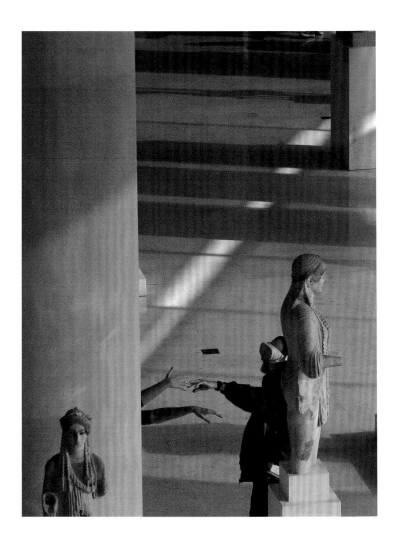

Symphony of a Missing Room, 2009
Installationsansicht / installation view,
Acropolis Museum, Athen / Athens, 2012

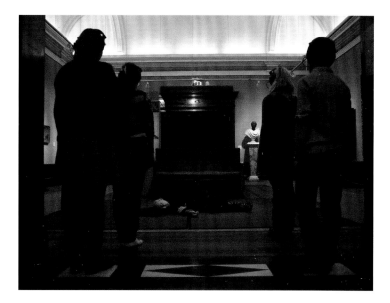

Symphony of a Missing Room, 2009
Installationsansicht / installation view,
Gothenburg Art Museum, 2010

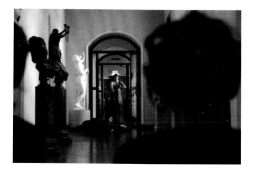

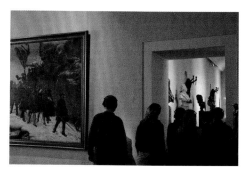

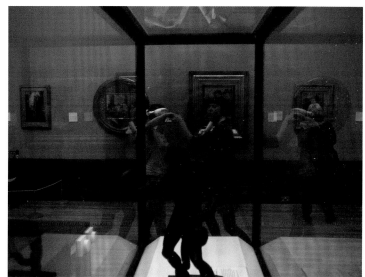

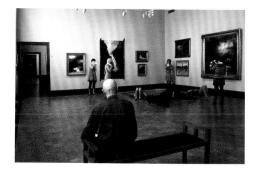

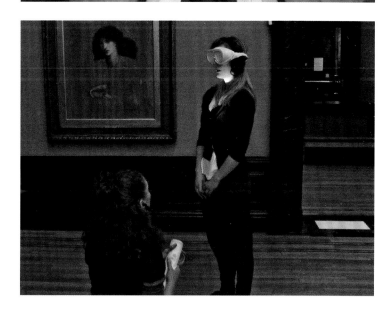

Symphony of a Missing Room, 2009
Installationsansicht / installation view,
Birmingham Museum & Art Gallery, 2011

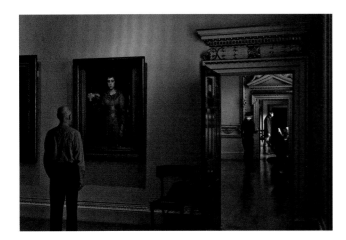
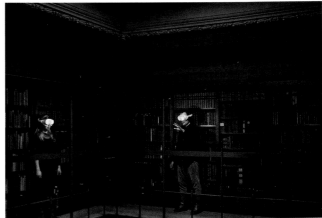

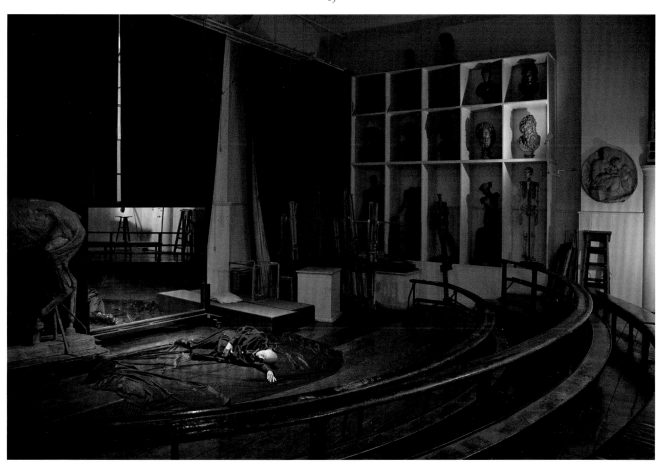

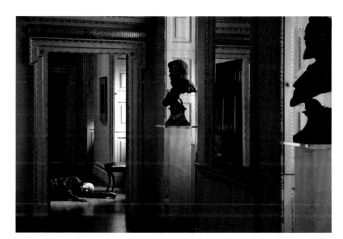
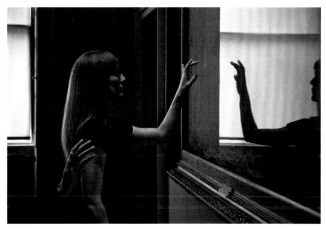

Symphony of a Missing Room, 2009
Installationsansicht / installation view,
The Royal Academy of Arts, London, 2014
Photos: Julian Abrams

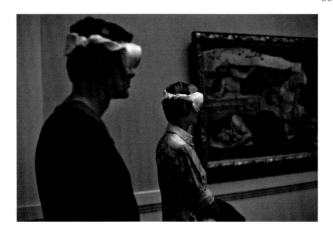
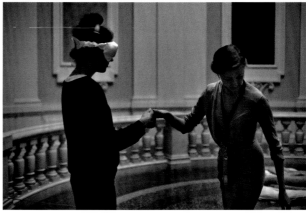
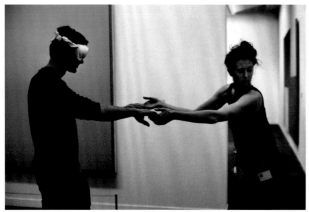
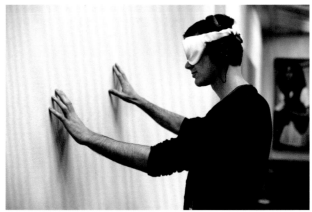
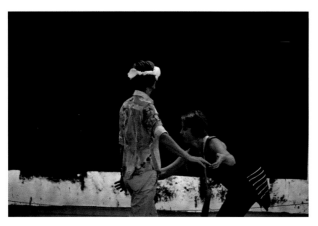
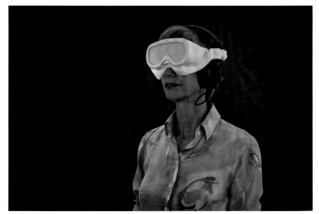
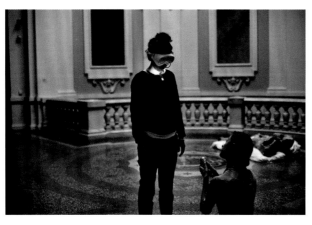
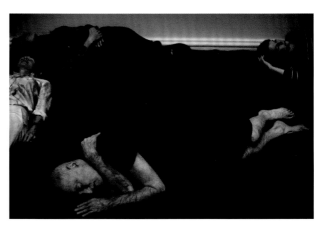

Symphony of a Missing Room, 2009
Installationsansicht / installation view,
Kunstmuseum Bern, 2014
Photos: Loulou d'Aki

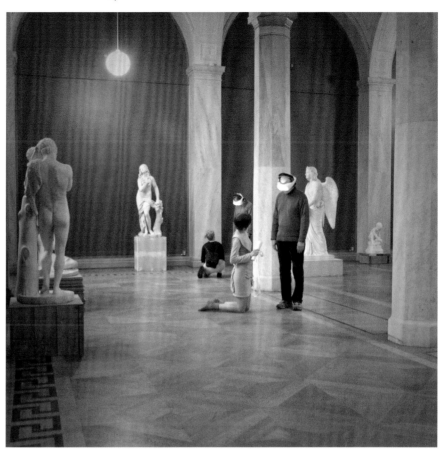

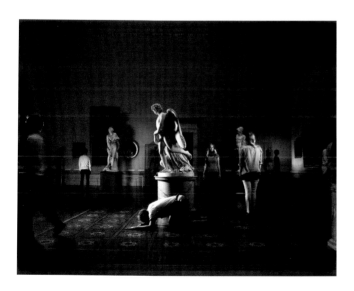

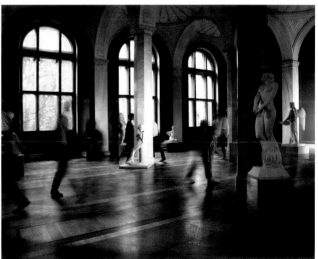

Symphony of a Missing Room, 2009
Installationsansicht / installation view,
Nationalmuseum, Stockholm, 2009.
Photos: Andreas Karperyd (oben / top),
John Gripenholm (unten / below)

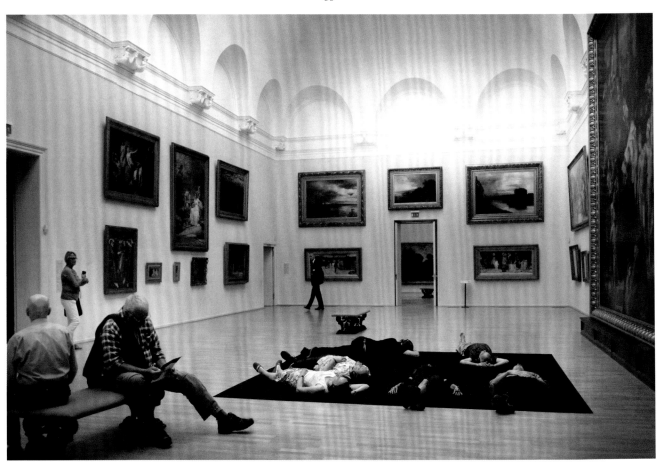

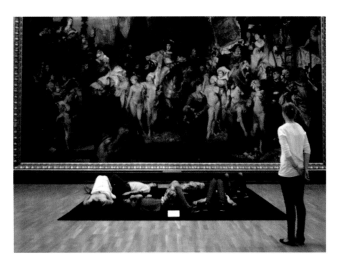

Symphony of a Missing Room, 2009
Installationsansicht / installation view,
Hamburger Kunsthalle, 2012
Photos: Antonia Zennaro (unten / below)

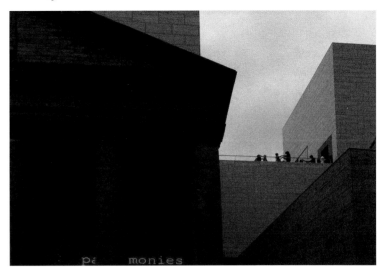

Symphony of a Missing Room, 2009
Installationsansicht / installation view,
SMAK-Museum of Contemporary Art, Gent 2010

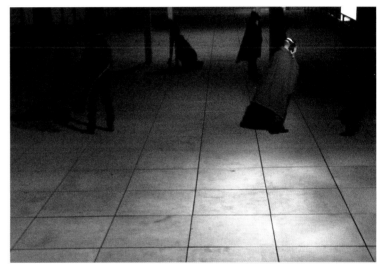

Symphony of a Missing Room, 2009
Installationsansicht / installation view,
Tunnel Vision, Momentum Kunsthall and
Galleri F15 Moss, Norwegen / Norway, 2016
Photos: Ingeborg Oÿyen Thorsland

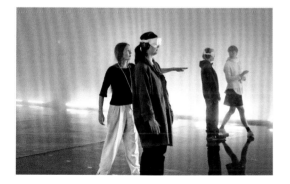

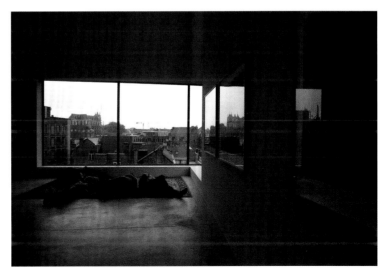

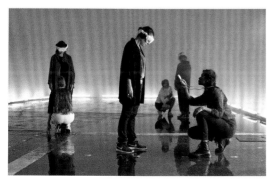

Symphony of a Missing Room, 2009
Installationsansicht / installation view,
Museum M, Löwen / Leuven, Belgien / Belgium, 2010

V

„In *The Infinite Conversation* erkannten wir, wie eine neue Bedeutung von Individuation entstand und fortwährend durch verschiedene BesucherInnen umgestaltet wurde – ein Ich, das nicht durch seine Beziehung zu anderen gekennzeichnet ist, sondern durch seine Beziehung zum Raum selbst."

Lundahl & Seitl

The Infinite Conversation findet in einem vollständig verdunkelten Raum statt, in dem die Besucherinnen und Besucher von Führern mit Nachtsichtbrillen an die Hand genommen werden. Sie treiben umher zwischen Inseln körperloser Stimmen, die miteinander im Gespräch sind, und können entscheiden, ob sie sich daran beteiligen oder nur still zuhören wollen. Jede neue Stimme wird in den Raum übertragen, wo sie einen Dialog mit anderen aufnimmt. Auf der Route, die sie wählen, erzeugen die Besucher und Besucherinnen mit den Stimmen, mit ihrer Bewegung durch den Raum sowie durch die Erfahrung und das Wissen, das sie mitbringen, ihre eigene Bedeutungskette. Die Galerie übernimmt und speichert diese Informationen in ihrem eigenen Gedächtnis – jede Besucherin, jeder Besucher hinterlässt eine Spur für die nächste Person.

Ähnlich wie die Höhlen von Lascaux ein archaisches Archiv vergangenen Lebens darstellen, bewahrt die Galerie den Informationsfluss entsprechend der Erinnerung und Aufmerksamkeit der jeweiligen Besucher und Besucherinnen in einem eigenen Pufferspeicher auf. Die Form des Werks ist nicht festgelegt, sondern erscheint eher als Habitus, der sich verändert, wenn es in eine neue Umgebung versetzt wird.

V

The Infinite Conversation

'*In The Infinite Conversation*, we noticed a new sense of individualisation being born and remade constantly by different visitors – a self defined not by its relationship to others, but by its relationship to the room itself.'

Lundahl & Seitl

The Infinite Conversation takes place in a blacked-out room in which visitors are led by the hand by guides wearing night-vision goggles. They drift between islands of disembodied voices in conversation, choosing whether to engage with the conversation or to silently listen in. Each new voice is projected out into the space, where it forms a dialogue with others. With their chosen route, visitors create their own chain of meaning from the voices, their movement around the space and the experience and knowledge they bring with them. The gallery absorbs and stores this information in its own inherent memory – every visitor leaves a trace behind for the next person.

The gallery, like the dark caves of Lascaux, keeps the flow of information in an intrinsic buffer, relative to each visitor's own memory and perceptions. The form of the work is not fixed but exists more as a habit, which changes when one is placed in a new environment.

VI

„Wir wollen die Nutzungsweisen von Museen und Theatern verändern. Unsere Arbeit spielt mit den Traditionen und Ritualen dieser Institutionen."

Lundahl & Seitl

In dieser Arbeit werden die vier Wände des Theaters entfernt, und ein virtueller Raum eröffnet sich im Geist und Körper der Besucher und Besucherinnen – dies ist nun der Ort, an dem das Kunstwerk stattfindet, seine Bühne. In einem Wechselspiel zwischen Klang der Architektur, Natur, menschlichen Stimmen und deren Verkörperungen – im Ungewissen darüber, wer die Beobachter sind und wer die Beobachteten – bewegen sich die Besucher und Besucherinnen auf einer choreografierten Route durch das Theater. Die grundlegenden Mechanismen dieser Kunstform spiegelnd, tauchen sie hinein in ein „Requiem auf das Theater" – ein Kunstwerk, in dem das Theater sich selbst spielt.

Zunächst werden die Besucher und Besucherinnen begleitet durch Stimmspuren von Schauspielern und Schauspielerinnen, die vor langer Zeit in dem Gebäude aufgetreten sind. Als Verkörperung der geisterhaften Gegenwart der Geschichte, der Ereignisse und Menschen aus der Vergangenheit, wird die Stimme dann auf einer verdunkelten Bühne aufgespürt und lokalisierbar: Wenn die Besucher und Besucherinnen die Hände ausstrecken, um zu ertasten, was offenbar die Quelle des Klangs ist, wird ihr inneres Bild kraft der Berührung einer Hand verkörperlicht, die ihre Imagination materialisiert.

VI

Proscenium

'We want to change the way museums and theatres are used. Our works play on the traditions and rituals of these institutions.'

Lundahl & Seitl

In this work, the four walls of the theatre are taken away and a virtual space is opened up in the visitor's mind and body – which effectively become the 'stage' where the artwork takes place. In an interaction between the sound of architecture, nature, people's voices and their embodiment – uncertain of who is the observer and who is the observed – visitors embark upon a choreographed route through the theatre. Reflecting back the mechanisms on which the art form is based, visitors become immersed in this 'requiem for the theatre', in an artwork where the theatre is playing itself.

At first, visitors are accompanied by traces of voices from actors who performed in the building long ago. Then, as an embodiment of the ghostly presence of history, events and people past, the voice is located and traced in a darkened stage; visitors reach out to touch what appears to be the source of the sound, and their internal images become embodied by the touch of a physical hand as a materialization of their imagination.

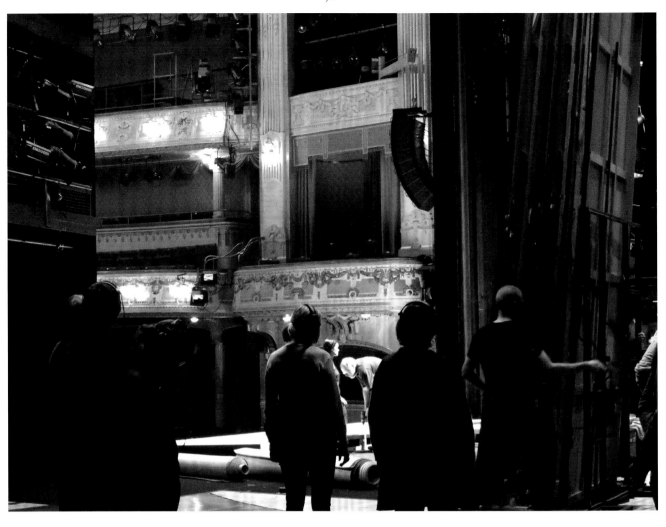

Proscenium, 2012 / Installationsansicht / installation view,
The Royal Dramatic Theatre, Stockholm, 2012

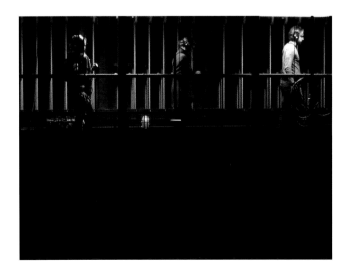

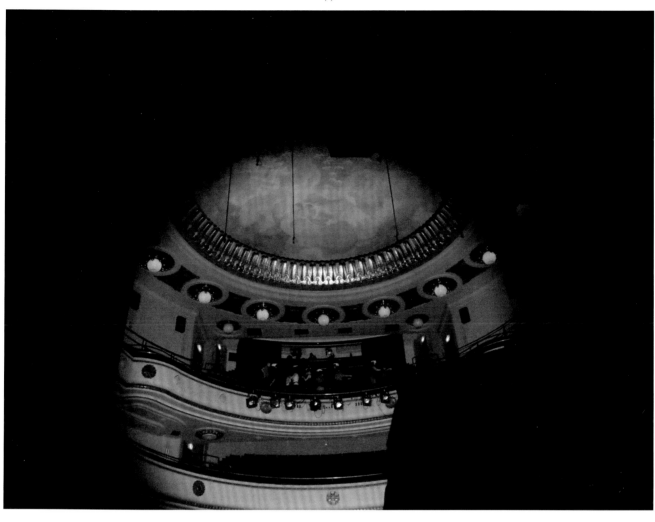

Proscenium, 2012 / Installationsansicht / installation view,
STUK 30cc, Löwen / Leuven, Belgien / Belgium, 2013

VII

An Elegy to the Medium of Film geht von der Annahme aus, dass aufgrund unseres umfangreichen inneren Filmspeichers nur wenige äußere Reize genügen, um uns ein Kinoerlebnis zu bereiten. Die Besucher und Besucherinnen betreten einen abgedunkelten Raum und nehmen dort Projektionen wahr, die sich nicht auf der Leinwand vor ihnen, sondern in ihrem eigenen Bewusstsein abspielen. Durch eine Mischung aus Videoprojektion, Audiomaterial und choreografierter Berührung wird die Einbildungskraft der Besucher und Besucherinnen in den Kinoraum projiziert. Die Besucher und Besucherinnen sollen die intersubjektive Erfahrung machen, in einen Film mit all seinen denkbaren Zeit- und Raumsprüngen einzutreten.

Dabei begegnen sie zunächst vertrauten filmischen Geräten, bis die Kamera ein eigenes Bewusstsein zu entwickeln scheint. Die Besucher und Besucherinnen werden eingeladen, den Leinwandrahmen zu durchschreiten und physisch in Szenen aus der Filmgeschichte einzutreten, an die sie sich erinnern. Dort werden sie dann freigesetzt, um sich zwischen narrativen Szenen, Klängen und Schauplätzen treiben zu lassen.

In *An Elegy to the Medium of Film* werden Weißblenden und Schwarzblenden zwischen geeignetes Material aus der Filmgeschichte gesetzt. Im Zusammenspiel mit einer körperlich-handgeführten Choreografie basierend auf Kamerabewegungen und Filmtechniken, werden wir von unsichtbaren Performern geleitet, und so schwenken, zoomen und fahren wir in unsere Erinnerung jener Bilder hinein, die wir soeben auf der Leinwand gesehen haben: Nachstellungen und Neubesichtigungen historischer Filmaufnahmen in 3D – fließende Einstellungen in historischer Architektur, darunter die Brueghel-Sammlung im Kunsthistorischen Museum Wien und der Aktsaal in der Royal Academy of Arts in London.

Wie andere Arbeiten ist auch diese eine Elegie auf eine Kunstform – in diesem Fall den Film – und die architektonischen Institutionen, in denen sie präsentiert wird. Neben der Geschichte erkundet sie aber auch die Zukunft von Film und Kino.

VII

An Elegy to the Medium of Film

An Elegy to the Medium of Film proposes the hypothesis that we all carry traces of films we have seen inside us and that we need very little external stimuli to create a cinematic experience. Visitors enter a darkened room in which they experience projections that play not on the screen in front of them, but in their own consciousness. Through a mix of video projection, sound and choreographed touch, the visitor's imagination is projected out into the cinema. The aim is for the visitor to become immersed in the inter-subjective experience of entering a film with all its potential leaps in time and space.

Visitors are first presented with familiar cinematic devices, until the camera seems to take on a consciousness of its own; they are then invited to move beyond the frame of the screen and physically enter scenes they remember from cinematic history. Subsequently they are set adrift in the history of film, floating between epic scenes, sounds and locations.

In *An Elegy to the Medium of Film*, whiteouts and blackouts are placed in between appropriated footage from film history. In tandem with a physical hand-led choreography, rooted in camera movements and film techniques, we are guided by unseen performers; panning, zooming and moving inside our memory of those images we recently saw on the screen: re-enactments of and revisits to historical film shots filmed in 3D, floating shots from historical architecture including The Breughel Collection at the Kunsthistorisches Museum Vienna and The Life Drawing Room at the Royal Academy of Arts in London.

Like other works, this piece is an elegy to an art form – in this case, film – and to the architectural institutions where the art form is presented. As well as being an elegy to the history of film, the piece explores the future of film and the cinema.

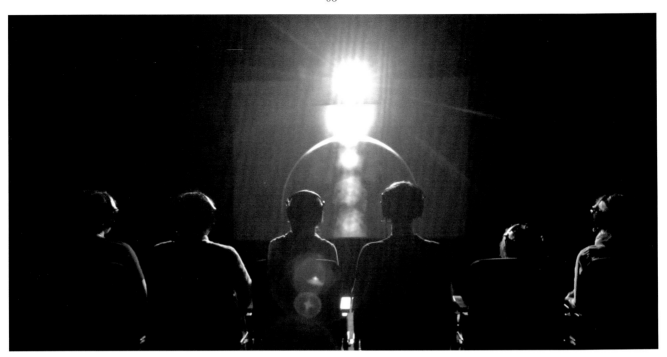

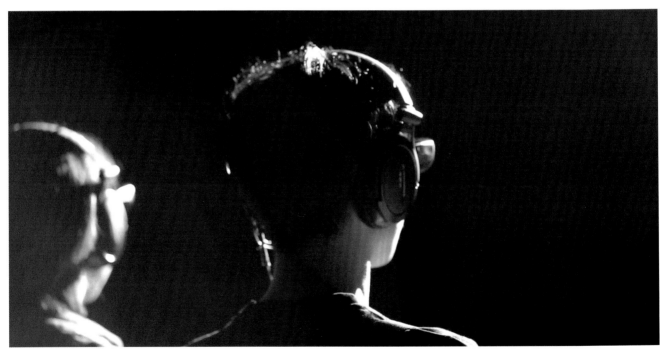

An Elegy to the Medium of Film, 2014
Installationsansicht / installation view, excerpt from the documentary
made by Wooran Foundation during *An Elegy to the Medium of Film*,
Seoul, South Korea, 2014

You transform yourself into a point of observation.

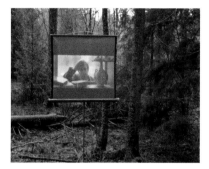

An Elegy to the Medium of Film, 2014
Stills aus dem Film / film stills

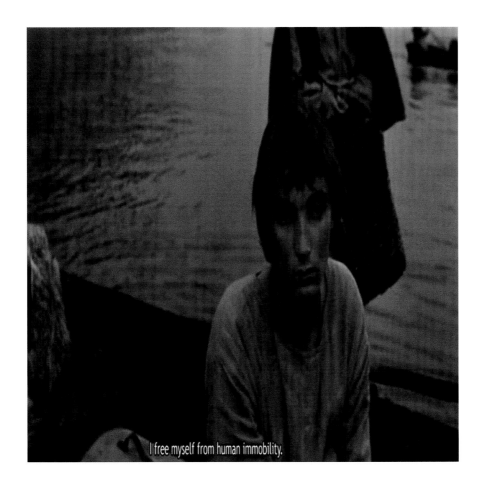

I free myself from human immobility.

An Elegy to the Medium of Film, 2014
Stills aus dem Film / film stills

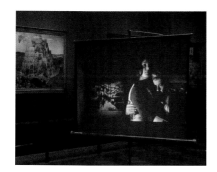

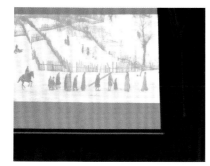

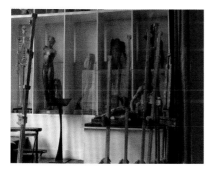

VIII

Beim Einsatz sondierender Wolkenradare und Langwellensender war ein Spannunganstieg zu erkennen, der offenbar auf zwei elektromagnetische Wolken hindeutet: eine Teilchen-Wellen-Formation, die einen Live-Austausch zwischen zwei getrennten Positionen auf ihrem Weg durch die Troposphäre aussendet.

Die Wolken erscheinen harmlos, können aber Daten lesen und speichern, die während der Kommunikation zwischen den beiden Positionen gesendet werden. Welche Eigenschaften diese Wolken im Lauf der Zeit entwickeln, bleibt unbekannt, doch werden sie derzeit – sofern sie sich beim Austausch räumlicher Positionen offenbar ständig in materialisiertem Zustand befinden – aus wissenschaftlichen Gründen nachverfolgt.

Nach Aussage von Menschen, die mit der Wolke interagiert haben, spielt diese mit einer evolutionären Schlüsselfunktion: unserer Fähigkeit, Geschichten zu erfinden und miteinander zu teilen, wodurch wir imstande sind, in großen Gruppen zusammenzuarbeiten und allen anderen Arten auf der Erde überlegen sind.

Unknown Cloud on its Way to Europe ist ein nomadisches Kunstwerk, das in Form einer digitalen Wolke über nationale Grenzen hinweg die Welt umrundet. Ganz ähnlich wie ein Wetterphänomen bewegt sich die Wolke, der Gerüchte über ihr Eintreffen vorauseilen, von Ort zu Ort. Eine sorgfältig geplante, in sozialen wie traditionellen Medien lancierte Kampagne sorgt für gesteigerte Erwartung und Neugier auf *The Cloud* als Phänomen – auf das, was sie ist und wofür sie stehen könnte.

Lundahl & Seitl sind nicht die Schöpfer der Wolke, sondern eher dafür verantwortlich, mithilfe fortgeschrittener Technologien ein Trackingprogramm zu entwickeln, um die Cloud-Daten über kabellose Kopfhörer empfangbar zu machen. Um den Strom der Live-Übertragungen anzuzapfen, lädt man eine Smartphone-App herunter und sucht den Wolkenbereich auf, in dem die Cloud wie eine Sonnenfinsternis innerhalb eines kleinen Zeitfensters aktiv ist. Die Teilnehmer können die Bewegungen der Wolke auf einer Online-Wetterkarte nachverfolgen und sich wie bei einem Flashmob an ihrem Standort einfinden: in einem Park, auf einem Platz oder auf einem Hügel oberhalb der Stadt.

Im Inneren der Wolke werden wir aufgefordert, einen Widerspruch zu erleben und uns etwas vorzustellen, das wir vor uns haben und nicht sehen können, mehr noch: auch Dinge, welche unsere physikalische Begrenztheit uns wahrzunehmen hindert – ferne Himmelskörper, Sterne, die schon lange erloschen waren, bevor es Menschen gab, die Erfahrung, auf einem Planeten zu stehen und zu begreifen, dass der Himmel sich auch nach unten fortsetzt und dass nicht die Sonne hinter dem Horizont versinkt, sondern wir uns rotierend von ihr entfernen. Während all dies die ganze Zeit um uns herum geschieht, wird es doch normalerweise nie erlebt.

Das Projektteam besteht aus einer ungewöhnlich zusammengesetzten Expertengruppe aus den Bereichen Kunst, Erlebnisdesign, Radio, Journalismus, Sozial- bzw. Digitalanthropologie, interaktive Digitaltechnik, virale Werbung und soziale Medien, Neurologie, Choreografie, Dramaturgie und avantgardistische Musikkomposition.

VIII

Unknown Cloud on its Way to Europe

Using scanning cloud radars and long wave transmitters, an initial power surge detected what appeared to be two electromagnetic clouds. A particle wave formation transmits a live feed between two separate locations as they move in the troposphere.

The clouds appear to be harmless but they are capable of reading and storing data transmitted during communication between the two locations. The temporal evolution of the properties of the clouds remains unknown, but for scientific reasons they are currently tracked, seemingly in a constant materialized state while interchanging spatial locations.

People interacting with the cloud have stated that it is playing on one key evolutionary function: that it is our ability to create and share stories that has made us good at collaborating in large groups, superior to any other species on earth.

Unknown Cloud on its Way to Europe is a nomadic artwork that travels across national borders around the world in the form of a digital cloud. The Cloud moves, much like a weather phenomenon, from place to place, preceded by a series of rumours about its arrival. Through a carefully engineered campaign, launched in both social and traditional media, anticipation and curiosity has built up around *The Cloud* as a phenomenon: around what it is, and what it may represent.

Lundahl & Seitl are not the creators of The Cloud, but rather are responsible for developing a tracking application, using advanced technology, to make its data accessible through cellular headphones. To tap into the stream of live transmissions one must download a smartphone app and relocate towards the area where the cloud is active within only a narrow time window, like a solar eclipse. Participants can track its movements on an online weather map and arrive at its location like a flashmob: at a park or a square, or on a hill above a city.

Inside The Cloud we are asked to experience a contradiction; to imagine something that is in front of us, that we cannot see – such things that our physical limitations prevent us from perceiving: faraway celestial bodies, stars extinct long before humans existed, the experience of standing on a planet and understanding that heaven also continues downwards and that it is not the sun that moves below the horizon but instead we who are rotating away from it – something happening around us all the time that is never consciously experienced.

The project team is made up of an unusual composition of experts in numerous fields, including art, experience design, radio, journalism, social/digital anthropology, digital interactive technology, viral PR and social media, neurology, choreography, dramaturgy and avant-garde musical composition.

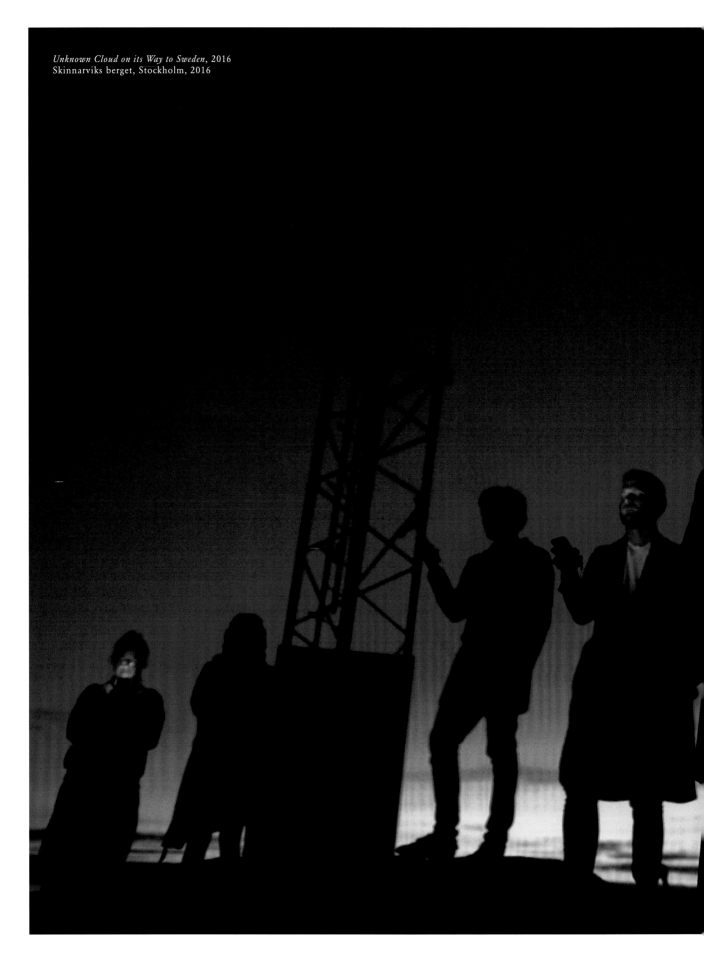

Unknown Cloud on its Way to Sweden, 2016
Skinnarviks berget, Stockholm, 2016

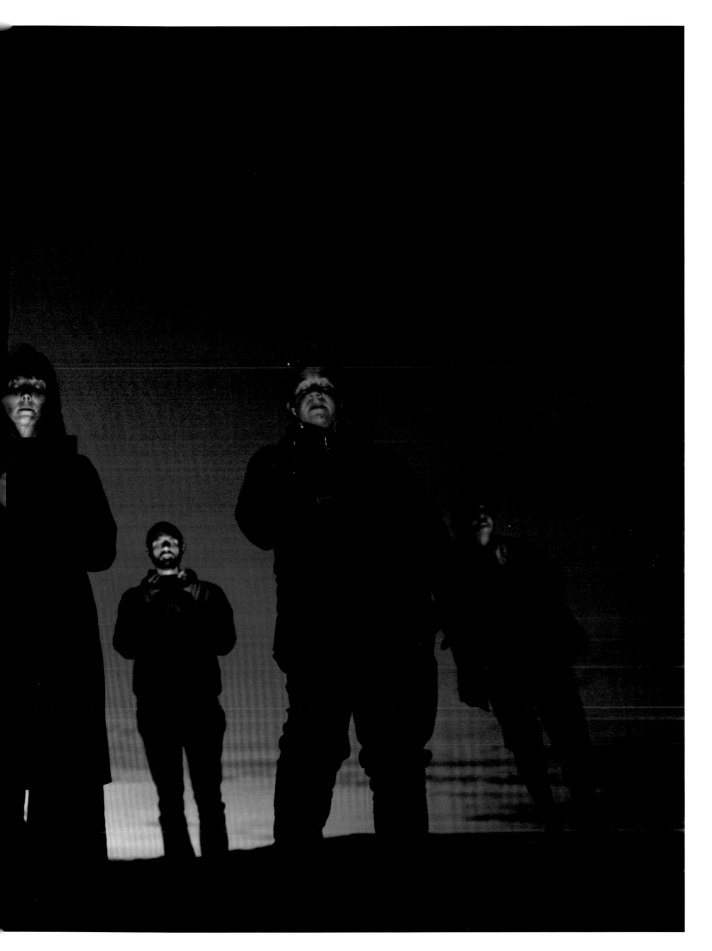

IX

Was geschieht, wenn historische Ereignisse frei flottieren, unabhängig von ihren Verankerungen in Büchern und Museen? *Symphony – The Mnemosyne Revolution* reflektiert über das Museum als Phänomen, seine Tradition und seine Zukunftsaussichten.

Im Mikrokosmos von *Symphony* überdauern die vergangenen Erlebnisse Einzelner die Zeit wie Sterne, die weiterhin scheinen, obgleich sie schon seit Lichtjahren tot sind.

Symphony – The Mnemosyne Revolution wurde als Teil der Ausstellung in Auftrag gegeben: ein imaginäres Museum, das eine fiktive Situation heraufbeschwört, in der die präsentierten Kunstwerke im Verschwinden begriffen sind. Besucher und Besucherinnen, die sich mit Arbeiten von KünstlerInnen wie Marcel Duchamp, Claes Oldenburg, Andy Warhol, Louise Bourgeois und Isa Genzken vertraut machen, sind eingeladen, diese in ihrem Gedächtnis zu bewahren und ihr eigenes „imaginäres Museum" zu erschaffen. Die Ausstellung ist aus einer Zusammenarbeit mit der Tate Liverpool und dem MMK Frankfurt hervorgegangen.

Der kuratorischen Vision des Gastgebers entsprechend zeigt diese neue Auftragsarbeit einen zukünftigen Zustand, in dem die von digitaler Technologie durchdrungenen Menschen aufgefordert sind, neu zu lernen, wie sich aus Sinnenerfahrung und Emotion Bedeutung schaffen lässt.

Dieses Kunstwerk ist kein Solitär. *Symphony* besteht aus dem potenziellen Sinnesaustausch zwischen zwei unvorbereiteten MuseumsbesucherInnen. Durch Anweisungen aus Kopfhörern geführt, lernen sie, sich ihre Erinnerungen an die Ausstellung zu eigen zu machen und im Zuge des Kunsterlebens herbeigeführte, tatsächlich verspürte Körperwahrnehmungen zu beobachten.

Das Kunstwerk soll sowohl ein Dokument der Kunstwerke in der Ausstellung sein als auch eine Partitur zur Erinnerung an eine Reihe bestimmter Gefühlsregungen, die in Zukunft in Vergessenheit geraten und verschwinden könnten.

IX

Symphony – The Mnemosyne Revolution

What happens when historical events float free of their bibliographic and museum anchorings? *Symphony – The Mnemosyne Revolution* reflects on the museum as phenomenon, its tradition and its potential futures.

In the micro-universe of *Symphony*, individual past experiences persist over time akin to the way that stars, although 'dead' light years ago, keep shining.

Symphony – The Mnemosyne Revolution was commissioned as a part of the exhibition *An Imagined Museum*, which conjured up a fictional situation in which the works of art on display were about to disappear. By familiarising themselves with pieces by artists such as Marcel Duchamp, Claes Oldenburg, Andy Warhol, Louise Bourgeois and Isa Genzken, members of the public were invited to preserve them in their memory and thus create their own 'imagined museum'. The exhibition was the result of a collaboration between Tate Liverpool and MMK Frankfurt.

Responding to the curatorial vision of its host, this new commission of *Symphony* proposes a future condition in which humans, immersed by digital technology, are prompted to relearn how to create meaning out of sensory experience and emotion.

This artwork is not a singular thing. *Symphony* consists of the potential sensory exchange between two untrained museum visitors. Receiving instructions through headphones, visitors are trained to internalize their memories of the exhibition and to observe induced, yet felt, bodily sensations in the process of experiencing art.

The artwork is intended to be both a document of the artworks in the exhibition as well as a score for remembering a series of defined emotions that in the future may be forgotten and disappear.

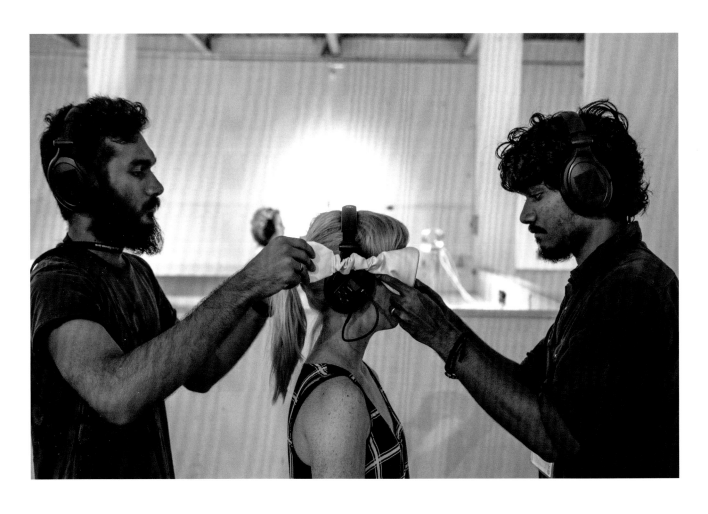

Symphony - The Mnemosyne Revolution, 2016
Kochi Muziris Biennale, Kerala, 2016
Photo: Kochi Biennale Foundation

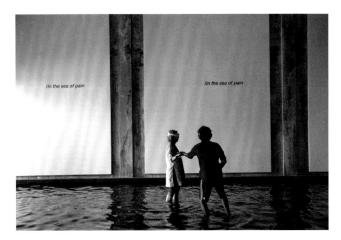

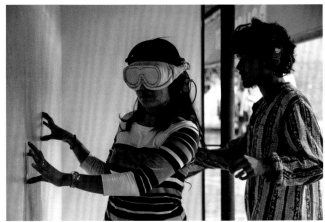

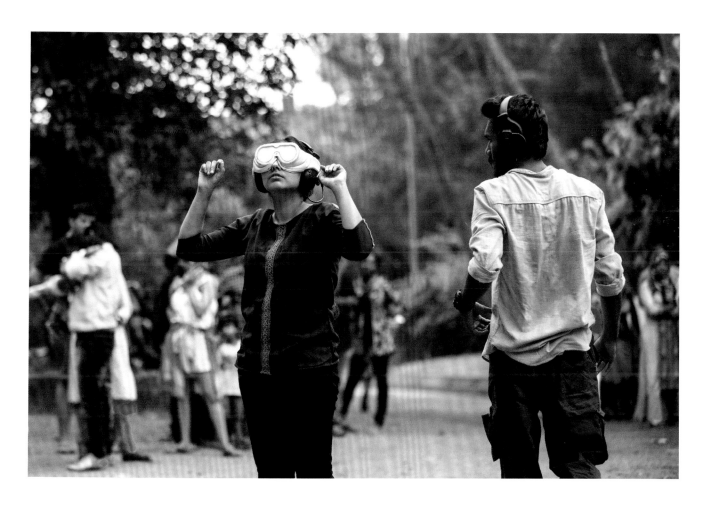

X

Neben der Abwandlung des Kunstwerks *Symphony of a Missing Room* haben Lundahl & Seitl das Werk *An Imagined Museum* konzipiert – in seiner weiterentwickelten Form *Memory of a Building* genannt. In dem Werk geht es darum, dass Besucher mit den Wänden des Museums sprechen können, das ihre Erinnerungen an Kunstwerke in seiner Architektur speichert. Diese Arbeit kann einerseits als autonomes Kunstwerk betrachtet werden, andererseits als ein Instrument zur Ermöglichung der Mitgestaltung.

Was wäre, wenn es keine Kunst mehr gäbe?
2052: Kunst ist in Gefahr, verboten zu werden – sogar ihr vollständiges Verschwinden droht … Über 80 zentrale Kunstwerke wurden in diesem bedrohten transnationalen Museum gerettet: Angesichts einer möglicherweise bevorstehenden Katastrophe müssen Wege gefunden werden, um diese Werke für künftige Generationen zu bewahren, indem sie erlebt und in unserer Erinnerung gespeichert werden.

Dieses fiktive Szenario ist der Ausgangspunkt der beispiellosen „Science-Fiction Ausstellung". Die Griechen, für die Mnemosyne, die Göttin der Erinnerung, die Mutter der neun Musen ist, erfanden etwa 500 Jahre v. Chr. eine Erinnerungstechnik, die darin bestand, jede erinnerungswürdige Idee mit einem mentalen Bild in einem architektonischen Raum zu verknüpfen.

Aus der Ausstellung: *An Imagined Museum*, Centre Pompidou-Metz, 2016.

Das Kunstwerk wurde im Zusammenhang mit dieser Ausstellung entwickelt.

X

An imagined Museum
Memory of a Building

Alongside the adaptations of the work *Symphony of a Missing Room*, Lundahl & Seitl have developed *An Imagined Museum*, or, as the further developed version is called, *Memory of a Building* where visitors can talk to the walls of the museum and the building 'saves' their memories of the artworks seen inside it. The work exists partly as an autonomous artwork and partly as a facilitating device for co-creation.

What if art were to disappear?

2052. Art is in danger of being banned; its total disappearance, even, looms ahead… Over eighty key works have been safeguarded within this endangered transnational museum; confronted with the possibility of an impending disaster, one must find the means to preserve these oeuvres for future generations by experiencing and memorizing them. This fictional scenario is the starting point for this unprecedented 'science-fiction exhibition'. The Greeks, for whom the goddess of memory, Mnemosyne, was the mother of the nine muses, invented a memorization technique around 500 B.C., which consisted of associating each idea one wanted to remember with a mental image located in an architectural space.

From the exhibition *An Imagined Museum*, Centre Pompidou, Metz, France, 2016.

The artwork was developed in connection with this exhibition.

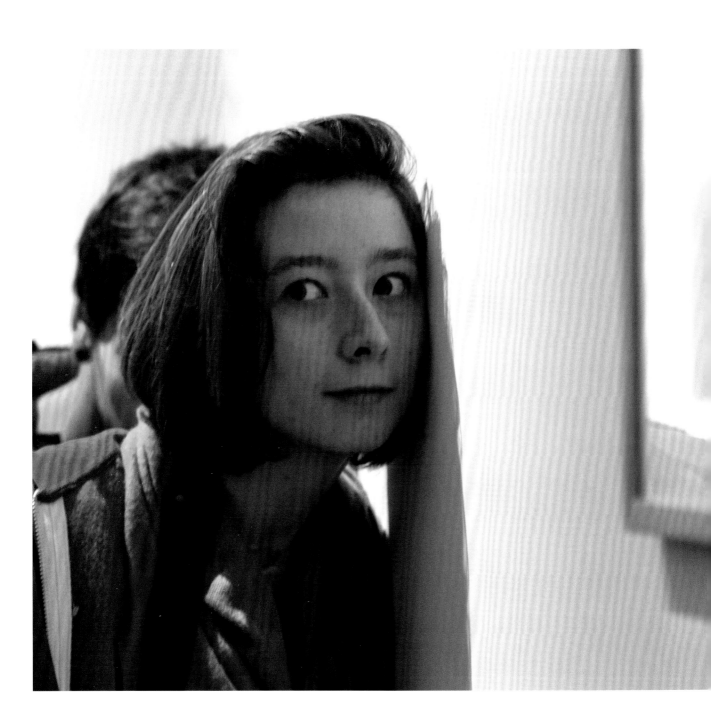

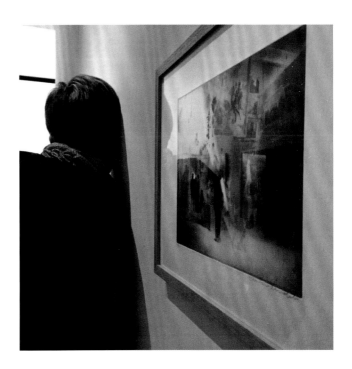

An Imagined Museum, 2016
Centre Pompidou Metz, 2016
Photo: René Garcia

Biografie · Biography

Christer Lundahl *1978 Jönköping, Schweden / Sweden

AUSBILDUNG / EDUCATION

2006 MA, Fine Art, Central Saint Martins, London
2004 BA, Academy of Art, Architecture and Design, Prag / Prague
2001 Diploma, Florence Academy of Art

Martina Seitl *1979 Jönköping, Schweden / Sweden

AUSBILDUNG / EDUCATION

2005 MA, Choreography & Performance Art,
Middlesex University, London
2004 Fine Art, Academy of Art, Architecture & Design,
Prag / Prague
2002 BA, Choreography, Laban Centre of Movement
and Dance, London

AUSGEWÄHLTE AUSSTELLUNGEN UND PROJEKTE /
SELECTED EXHIBITIONS AND PROJECTS

2017 *New Originals*, Kunstmuseum Bonn
2016 *Symphony – Kochi-Muziris Biennale*, Kochi-Muziris Biennale
(India)
Unknown Cloud on its way to Kópavogur, Cycle Music and
Art Festival (Iceland)
Symphony, Martin-Gropius-Bau, Berliner Festspiele (Germany)
*Symphony of a Missing Room – An Imagined Museum, Symphony –
The Mnemosyne Revolution*, Centre Pompidou-Metz (France)
Symphony, Museum für Moderne Kunst, Frankfurt/M. (Germany)
An Elegy to the Medium of Film, Göteborg Dans & Teater Festival
(Sweden)
An Elegy to the Medium of Film, Wooran Foundation (South Korea)
2015 *Symphony – Momentum*, Punkt Ø, Momentum 8
Tunnel Vision, Nordic Biennale of
Contemporary Art, Moss (Norway)
An Elegy to the Medium of Film, Noorderzon Performing Arts
Festival Groningen (Netherlands)
2014 *Symphony of a Missing Room*, Royal Academy of Arts
and LIFT (UK) and Kunstmuseum Bern, commissioned by
Biennale Bern (Switzerland)
Farkost, urSinnen, Färgfabriken (Sweden)
An Elegy to the Medium of Film, Schauspielhaus Graz,
commissioned by Steirischer Herbst (Austria)
2013 *Proscenium*, 30CC, commissioned by STUK (Belgium)
Attachment at National Theatre Studio (UK)
The Memory of W.T. Stead, collaboration with experimental pianist
Cassie Yukawa, commissioned by Nomad, Steinway Piano
Showroom, London (UK)

2012 *Proscenium*, co-production between Dramaten
(Royal National Theatre) and Lundahl & Seitl (Sweden)
Symphony of a Missing Room, Acropolis Museum, commissioned
by Mir Festival (Greece)
Rotating in a Room of Images, Röda Sten Konsthall, Gothenburg
(Sweden)
The Infinite Conversation, commissioned by Avignon Festival (France)
Symphony of a Missing Room, Hamburger Kunsthalle, commissioned
by Kampnagel (Germany)
The Viewer as a Medium – Imagining the Audience (seminar),
co-production MAP and Riksutställningar, Rio Rio, Stockholm
(Sweden)
2011 *Observatory*, MDT, Stockholm (Sweden)
The Infinite Conversation, PerformanceExhibition, Magasin 3 (Sweden)
Rotating in a Room of Images, STUK, Leuven (Belgium)
Symphony of a Missing Room, S.M.A.K. Museum of Contemporary
Art, commissioned by Vooruit for *The Game is Up!*, Ghent (Belgium)
Symphony of a Missing Room, Birmingham Museum & Art Gallery,
Fierce, Birmingham (UK)
2010 Residency at 1 Shanthi Road Arts Centre, Bangalore (India)
Symphony of a Missing Room, Museum M, Leuven (Belgium)
My Voice Shall Now Come From the Other Side of the Room, Roma Art
Fair, Rome (Italy)
Symphony of a Missing Room, Gothenburg Museum of Art,
commissioned by Gothenburg International Festival (Sweden)
Principles of Allowing the Self to Be Lost (seminar), an investigation
into process in research, Karolinska Institute of Cognitive
Neuroscience (Sweden)
Choreographing Absence – the Viewer as a Medium (seminar) DI and
EMS, Stockholm (Sweden)
2009 *Symphony of a Missing Room*, National Museum, co-production
by Weld (Sweden)
My Voice Shall Now Come From the Other Side of the Room, A
Foundation, London (UK)
Rotating in a Room of Images, Battersea Art Centre, London (UK)
Martina's Birthday, Cell Project Space, London (UK)
Christer's Birthday, Summer Institute, Tate Modern, London (UK)
2008 *Work/Workshop*, Weld, Stockholm (Sweden)
My Voice Shall Now Come From the Other Side of the Room,
Beaconsfield Gallery (UK)
2007 *Recreational Test Site*, Weld, Stockholm (Sweden)
My Voice Shall Now Come From the Other Side of the Room, Late at Tate,
Tate Britain (UK)
Explode and (Anything) – An Itinerary, BAC Project Space, Battersea
Arts Centre (UK)
Birth Series, Greedy Magpie, Whitechapel Gallery (UK)

KURATORISCHE ARBEIT / CURATORIAL WORK

2013 *BAUER*, an exhibition curated by Lundahl & Seitl,
Jönköping Läns Museum (Sweden)
2012 *Vita Kuben*, a project exploring curatorial collaboration –
an exhibition in three parts, Vita Kuben Norrlands Operan (Sweden)
2007 *We May Never Pass This Way Again*, Battersea Arts Centre (UK)
2006 *Knee-Jerk*, Byam Shaw School of Art (UK)
2005 *Seventeen Principles of Co-Existence*, Lauderdale House,
London (UK)

www.lundahl-seitl.com

Copyright · Credits

Thanks from the artist duo:

We are so, so thankful to our collaborators, the "unseen"
but most present guides of the visitors of our work:

Performers: Genevieve Maxwell, Sara Lindström,
Rachel Alexander, Laura Hemming Love, Pia Nordin,
Lisette Drangert, Catherine Hoffmann, Colin McLean

To our Lead Technical Designer: Jan Carleklev

To Unknown Cloud's Social Media Director:
Anna J Ljungmark, and Markus Bohm, Jûrgen Königsmann
and Morgan Fredriksson at Nagoon.

An immense gratefulness to Emma Leach who managed our
projects from 2010 until 2016, when she decided to move
further to work with British Artist: Mike Nelson.

Lundahl & Seitl

Impressum · Imprint

Dieses Buch erscheint anlässlich der Ausstellung / This book is published in conjunction with the exhibition

Lundahl & Seitl
New Originals

9. März – 28. Mai 2017
9 March – 28 May 2017

Kuratorin / Curator
Sally Müller

KUNSTMUSEUM BONN
Friedrich-Ebert-Allee 2
D-53113 Bonn
www.kunstmuseum-bonn.de

Intendant / Director
Stephan Berg

Ausstellung und Katalog /
Exhibition and Catalogue
Sally Müller

Verwaltung / Administration
Gabriele Kuhn
Vera Scheel

Registrar
Barbara Weber

Ausstellungssekretariat /
Exhibition Administration
Iris Lölsberg
Kristina Georgi

Presse und Öffentlichkeitsarbeit /
Press and Public Relations
Anne Fischer

Marketing
Antonia Buning

Bildung und Vermittlung /
Education
Sabina Leßmann

Restauratorische Betreuung /
Art Conservation
Antje Janssen
Nicole Nowak

Leitung der Werkstätten /
Heads of Workshops
Reinhard Behrenbeck
Martin Wolter

Ausstellungstechnik /
Exhibition Technology
Josef Breuer
Martin Kerz

Dank an / Thanks to:
Projektmanagerin / Project
Manager, Lundahl & Seitl:
Nina Overli; Kurzgeschichte /
Short story: Alex Backstrom;
Geräuschemacher / Foleyartist:
David Osterberg; Deutsche
Stimme / German voice:
Nina Herting; Spezialbrillen /
Sightless Goggles: Jula Reindell;
Filmproduktion / Film
Production: Joakim Olsson
Wachpersonal / Invigilators at
Kunstmuseum Bonn

KATALOG / CATALOGUE

Autoren / Authors
Stephan Berg, Intendant des
Kunstmuseum Bonn / Director
of Kunstmuseum Bonn

Ronald Jones, Künstler und
Professor für Service Design am
Royal College of Art London /
Artist and Senior Tutor for
Service Design at Royal College
of Art London

Sally Müller, Kuratorin
für Gegenwartskunst,
Wissenschaftliches Volontariat
am Kunstmuseum Bonn,
2015 – 2017 / Curator for
Contemporary Art, Assistant
Curator at Kunstmuseum Bonn,
2015 – 2017

Johan Pousette, Direktor für
das Iaspis Program Stockholm /
Director for the Iaspis
Programme Stockholm

Redaktion / Editing
Sally Müller
Projektmanagement Verlag /
Project management publisher:
Jana Ronzhes
Übersetzung Translation:
Stefan Barmann (Englisch –
Deutsch / German – English),
Kristina Georgi (Englisch –
Deutsch / German – English)
Lisa Martin (Schwedisch –
Englisch / Swedish – English),
George Frederik Takis
(Deutsch – Englisch /
German – English)
Lektorat Deutsch / Copyediting
German: Barbara Delius
Lektorat Englisch / Copyediting
English: Sarah Quigley

Gestaltung / Graphic Design
Adeline Morlon

Gesamtherstellung / Production
Wienand Verlag, Köln
www.wienand-verlag.de

WIENAND.

Fotonachweis / Photo Credits
Wenn nicht anders vermerkt,
sind die Fotografien von
Lundahl & Seitl gestellt und
fotografiert worden.
Unless otherwise stated,
photographs were supplied by
Lundahl & Seitl.

Andere Fotografen /
Other photographs

Luca Signorelli, Man on
a Ladder © The National
Gallery, London. Accepted by
HM Government in Lieu of
Inheritance Tax and allocated to
the National Gallery, 2016

Abbildungen / Illustrations
Umschlag Vorderseite /
Front cover:
Neues Original / New Original:
aus der Erinnerung von /
as remembered by Christer
Lundahl, Zeichnung auf Papier /
drawing on paper, 2017.

Umschlag Rückseite /
Back cover:
Neues Original / New Original:
aus der Erinnerung von /
as remembered by Christer
Lundahl, Zeichnung auf Papier /
drawing on paper, 2017.

ISBN 978-3-86832-390-0

Bibliografische Information der
Deutschen Nationalbibliothek:
Die Deutsche National-
bibliothek verzeichnet diese
Publikation in der Deutschen
Nationalbibliografie; detaillierte
bibliografische Daten sind im
Internet abrufbar über:
http://dnb.d-nb.de

Bibliographic information
published by the Deutsche
Nationalbibliothek
The Deutsche National-
bibliothek lists this
publication in the Deutsche
Nationalbibliografie; detailed
bibliographic data are available
on the Internet at:
http://dnb.d-nb.de.

Mit großzügiger Unterstützung von /
With the generous support of

 Stiftung Kunst
der Sparkasse in Bonn

In Kooperation mit / In cooperation with

FREUDE.
JOY.
JOIE.
BONN.

 Ⓚ | THE SWEDISH ARTS GRANTS COMMITTEE

SWEDISH
ARTSCOUNCIL

Nagoon
Spatial Intellegence